POSTCARD HISTORY SERIES

Chestertown
and Kent County

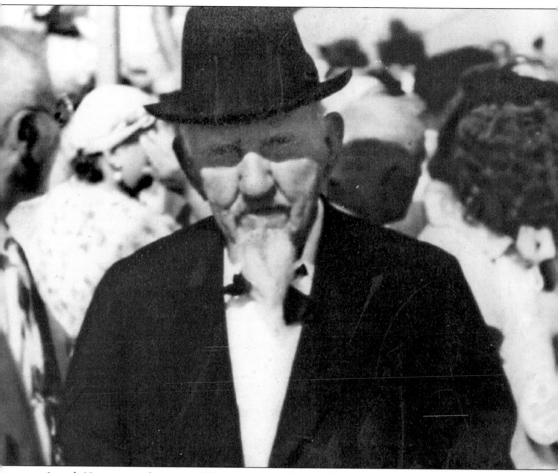

Joseph Hynson was known as "Kent County's Grand Old Man." He is also fondly remembered as "Captain Hynson" and "Old Uncle Joe." He was one of the oldest Civil War veterans of this country. He died at age 103 at his home, Hynson's Haven near Rock Hall, which he built for his bride, Sarah Leonora Ayres, in 1860. He helped construct the Rock Hall Methodist Church, where he was a member for almost 90 years. Hynson served in Company D, 1st Maryland Regiment, 2nd Division, 5th Corps, of the Union army under Gen. Ambrose Everett Burnside's command. He was at Appomattox when Lee surrendered. He was a member of the National Council of the Grand Army of the Republic (GAR).

POSTCARD HISTORY SERIES

Chestertown and Kent County

R. Jerry Keiser, Patricia Joan O. Horsey,
and William A. (Pat) Biddle

ARCADIA
PUBLISHING

Published by Arcadia Publishing
Charleston, South Carolina

Printed in the United States of America

Library of Congress Catalog Card Number: 2005930788

For all general information contact Arcadia Publishing at:
Telephone 843-853-2070
Fax 843-853-0044
E-mail sales@arcadiapublishing.com
For customer service and orders:
Toll-Free 1-888-313-2665

Visit us on the Internet at www.arcadiapublishing.com

ABOUT THE AUTHORS

William "Pat" Biddle, a Kent County native, began collecting postcards at a very early age. What began as childhood entertainment became a lifelong hobby. He particularly enjoys creating shadowboxes with postcards in the background that illustrate the history of the Eastern Shore, including Tolchester and Betterton resorts that flourished in the 1920s and 1930s. All of his shadowbox figures are dressed in period costumes. He hopes all will enjoy this book of his postcards as much as he has. Pat retired a few years ago after a long career as an educator.

Patricia Joan O. Horsey is a lifelong resident of Kent County with an interest in history and genealogy. Her colleague, R. Jerry Keiser, is a local historian and librarian.

CONTENTS

ACKNOWLEDGMENTS

The authors have put together this collection of postcard history for all to enjoy, especially Barbara and Glen Biddle and Gabriela, Claudia, and Nathan Biddle; Frank Ozman Smith, Carli Crew Smith, James Thomas Ozman Landon, Baker Fallon Horsey Landon, Kathryn Macey Smith, Jennifer Ashley Horsey, and Lauren Nicholson Horsey; and Jacob and Evelyn Keiser.

INTRODUCTION

The Chester River flows through much of the Delmarva Peninsula from its source near Smyrna, Delaware, until it empties into the Chesapeake Bay. As the river meanders its way through Maryland's Eastern Shore, it forms the southern boundary of Kent County. It is on the banks of the Chester River in Kent County that the town of "New Town," which was Chestertown's original name, would be established by an act of Maryland in 1706. The town was situated on the banks of the river on a tract of land called Tilghman and Foxely Grove. The following year, the town and port at Yarmouth were ordered deserted. A courthouse was then built at New Town. The town of New Town changed its charter and its name in 1780 to Chester Town.

Chestertown was designated as the port of entry for the northern counties of Cecil, Kent, and Queen Anne's Counties. Chestertown is a quiet, quaint Colonial town that has maintained most of its 18th-century architecture and history, both of which are on display every Memorial Day weekend for the Chestertown Tea Party. This annual event commemorates the boarding of the brigantine *Geddes*, anchored in the Chester River, on May 23, 1774. A group of citizens tossed the *Geddes's* cargo of tea into the Chester River in response to the closing of the Port of Boston.

In addition to dissenting against Great Britain's course of action toward the colonies, Chestertown and Kent County contributed men, arms, and food to America's war for independence. Kent County was the most vital source on the Eastern Shore for armaments, and the county's farmers' and millers' contribution to the war is one reason the Eastern Shore has been referred as the "Bread Basket of the Revolution."

Finally, Revolutionary War hero Lt. Col. Tench Tilghman, carrying the news of Gen. Charles Cornwallis's capitulation at Yorktown, crossed the Chesapeake Bay by ferry, landing at Rock Hall. Tilghman then galloped through Kent County toward the Congress at Philadelphia.

With the war finally over, the citizens of Kent County returned to their farms and mercantile affairs and to tending to the proper education of their young men. It was in Kent County, in the town of Chestertown, that Washington College was founded in the year 1782. Washington College has been a significant part of Kent County history. It was the first college founded in the new nation of the United States of America. It was named for Pres. George Washington and was the only college to receive his "expressed consent" and monies donated to its founding. Throughout his life, Washington's connection with the school became a source of historical pride for the residents of the county.

However, the peace that had existed for almost 40 years between Britain and America would come to an abrupt end when Britain invaded America in 1812. The British routinely raided and burned towns along the shores of the Chesapeake Bay. In May 1813, Georgetown on the Sassafras

River in Kent County became one of their targets. The Kitty Knight House, which sits on a hill overlooking the Sassafras River, is one of the few houses that were spared the torch on the night of May 5, 1813, because Miss Knight pleaded with the British not to burn her neighbor's house or her own. It is because of her heroism that several houses in Georgetown were spared. The Kent County militia would finally meet up with the British at the Battle of Caulk's Field and force the British out of Kent County.

Kent County, its towns, and its villages continued to play an important role in Maryland and U.S. history. Mason and Dixon would spend time surveying the boundary line between Maryland and Delaware, the Civil War would claim 400 of our citizens, thousands would come and play at our beaches at Betterton and Tolchester, and women would vote before the 20th Amendment made it legal.

It is our hope that this postcard narrative will provide a glimpse into the cultural landscape and history of Chestertown as it celebrates its tercentennial and that non-residents will discover that Chestertown and Kent County is a great place to visit and even a greater place to live and experience history in the making.

The proceeds from the sale of this book go to the Foundation for the Kent County Public Library.

One

CHESTERTOWN

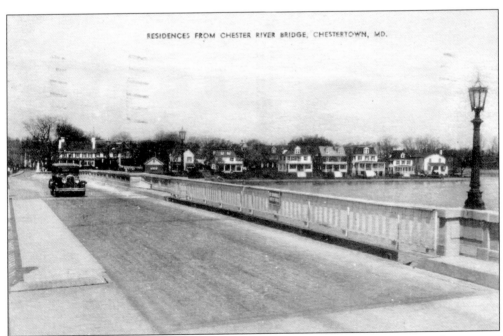

RESIDENCES FROM CHESTER RIVER BRIDGE, CHESTERTOWN, MD.

The residences that can be seen coming across the Chester River Bridge into Chestertown are located on Water Street and remain today. A wooden bridge was built in 1805 across the Chester River at the foot of Maple Avenue (then Fish Street) next to first house on the right of the bridge, a three-bay brick Georgian house first constructed in the mid-18th century. A small tollhouse, which collected tolls until the bridge was made free in 1890, was built at the edge of this property.

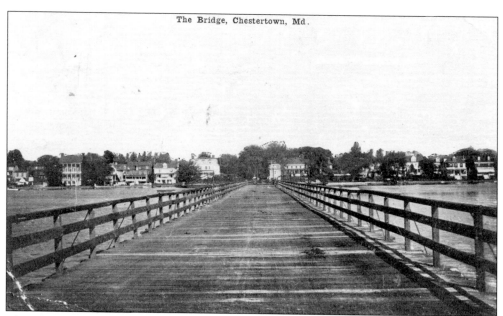

The Chester River Bridge began with a legislative act of 1804 that levied money in Kent and Queen Anne's Counties for a bridge over the Chester River at Chestertown. Subscriptions were taken for stock in the Chester River Bridge Company at $50 per share. In 1812, a scheme for a lottery was published consisting of 16,000 tickets at $6 each (a total of $96,000). In 1819, notice was given that subscriptions for stock were open again. The Maryland State Roads Commission assumed ownership of the bridge in 1914, and a concrete bridge replaced the old wooden bridge in 1929.

HUPMOBILE
FOURS AND EIGHTS

HUPMOBILE **is the type of dependable value that makes a quick appeal to every experienced, clear thinking buyer. It has an uninterrupted record of good will covering a period of sixteen years. Everybody knows that the Hupmobile is an honest car—correctly designed, carefully built, fairly priced.**

The new models are very beautiful and are finer in all details. You must be sure to see them. Come in soon.

C. A. BACON
Maple Ave. Garage, Chestertown, Md.

This postcard advertised the Hupmobile, four- and eight-cylinders, for sale at C. A. Bacon Garage on Maple Avenue in Chestertown. They were built by Robert Craig Hupp. "Hupmobile is the type of dependable value that makes a quick appeal to every experienced, clear thinking buyer. It has an uninterrupted record of good will covering a period of sixteen years. Everybody knows that the Hupmobile is an honest car—correctly designed, carefully built, fairly priced. The new models are very beautiful and are finer in all details. You must be sure to see them. Come in soon."

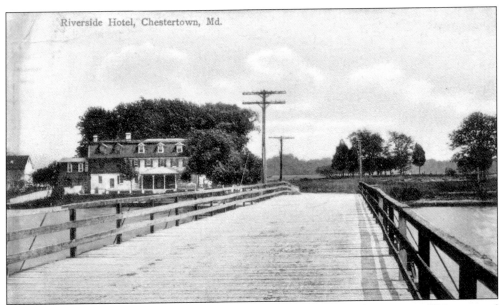

Riverside Hotel, Chestertown, Md.

The Riverside Hotel is located on the Chester River across from Chestertown. This postcard was published by Rote the Jeweler and was made in Germany. The Riverside Hotel is located on the Queen Anne's County side of the Chester River and overlooks Chestertown's waterfront. This wooden Chester River Bridge was built in the early 1900s and was replaced and moved to the left side of the hotel. The hotel remains today as a liquor store and marina.

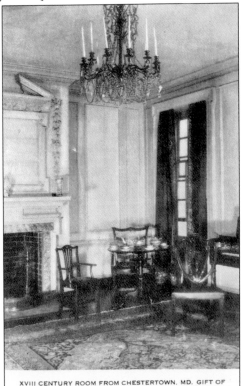

The paneling from this 18th-century room, *c.* 1771, is from the Hynson-Ringgold House in Chestertown and, according to the postcard, was a gift to the Baltimore Museum of Art by Mrs. J. H. Johnson. The Baltimore Museum of Art confirmed that they received the paneling in 1932. The postcard was published by the Artvue Postcard Company at 225 Fifth Avenue, New York, New York.

XVIII CENTURY ROOM FROM CHESTERTOWN, MD. GIFT OF MRS. J. H. JOHNSON. BALTIMORE MUSEUM OF ART

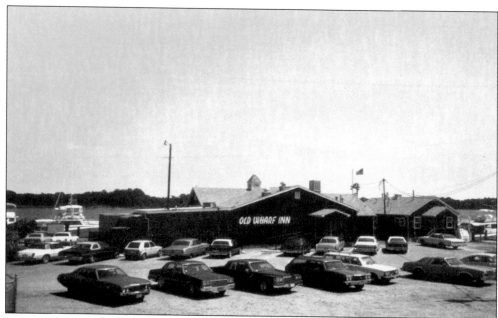

This postcard states: "The Old Wharf Inn was built in 1975 on the scenic Chester River at Chestertown. The restaurant specializes in seafood dishes, but is a full menu restaurant with salad bar and cocktails for fine family dining. It is adjacent to Kibler's Marina which as 54 slips. Part of these slips are retained for transient boats." The Old Wharf fell victim to Hurricane Isabel in 2003 and was totally rebuilt in 2004. This postcard was published by Dynacolor Graphics, Inc., in Miami, Florida, and distributed by HPS, Inc., of Dover, Delaware.

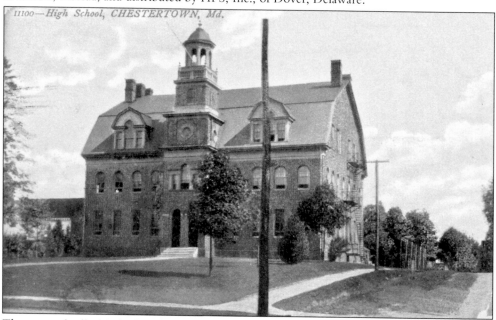

The postcard calls this the "High School." This building is located on High Street in Chestertown and was once an elementary school with grades one through six. It serves today as the Kent County Government Office Building. It was a costly building for the period. The original cupola on the stair tower was removed in 1956.

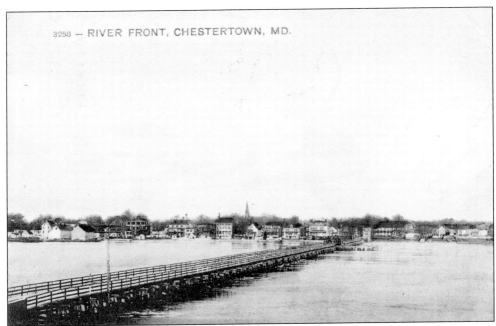

3258 — RIVER FRONT, CHESTERTOWN, MD.

This picture of the River Front of Chestertown was published as postcard No. 3258. This is the view of the waterfront along Water Street with the First Methodist Church steeple looming in the background. Distinguishable 18th-century houses are Widehall to the far left and River House, also to the left of the bridge and in the center of the block.

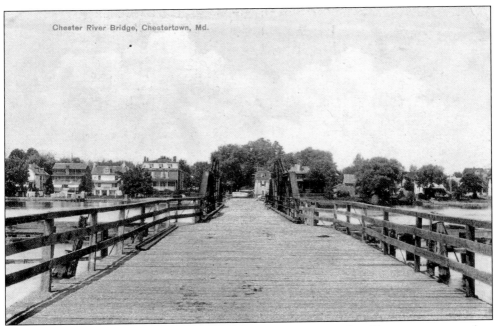

Chester River Bridge, Chestertown, Md.

The Chester River Bridge, along Maryland Route 213 upon entering Chestertown, was taken over by the Maryland State Roads Commission in 1914, and a concrete bridge replaced the old wooden one in 1929.

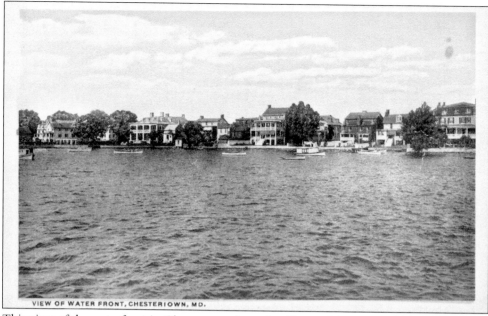

This view of the waterfront in Chestertown from the Chester River Bridge welcomes a lot of visitors. Homes dating to the 18th century line the waterfront, bearing venerable witness to the town's long and exciting history.

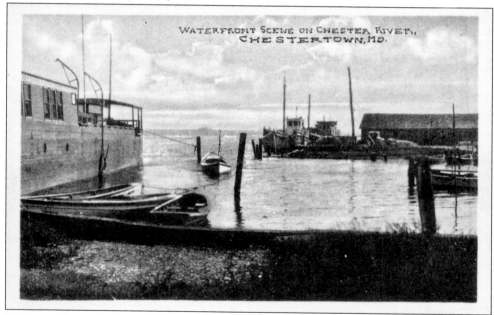

This waterfront scene on the Chester River in Chestertown shows a number of boats along the shore and docked at the waterfront. The waterfront has always been an important part of Chestertown's history. In 1877, Taylors Wharf was located next to the fruit canning factory on the Chester River at the foot of High Street. There was also a county wharf and a steamboat wharf at the foot of High Street. Joseph Turner established a sawmill and lumberyard at Scott's Point in 1883. It later was owned by Crane and Trenchard, who manufactured peach baskets. This postcard was published by Louis Kaufmann and Sons, Baltimore, Maryland.

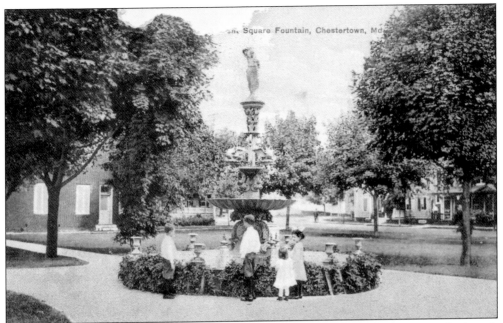

The Fountain in the Park in Chestertown was a project of the Ladies Improvement Society. It was dedicated in 1899. Hebe, goddess of youth and beauty and cupbearer to the gods, stands atop the ornate cast-iron fountain. This postcard was published by M. A. Toulson Apothecary, Chestertown, and it is postmarked at Chestertown in 1914. Its markings include: Newvochrome ANC, New York; Leipzig, Dresden, Berlin, Germany.

Many of Chestertown's earliest houses belonged to wealthy merchants in the shipping business who lived on Water Street. Widehall was built by Thomas Smythe *c.* 1770. Thomas Smythe was one of Kent County's wealthiest citizens and also owned 400 acres on Eastern Neck called Trumpington. He was a builder, a merchant, and a shipbuilder. He was also the first treasurer of Washington College in 1782. The house is noted for magnificent Georgian architecture with a gracious lawn to the Chester River.

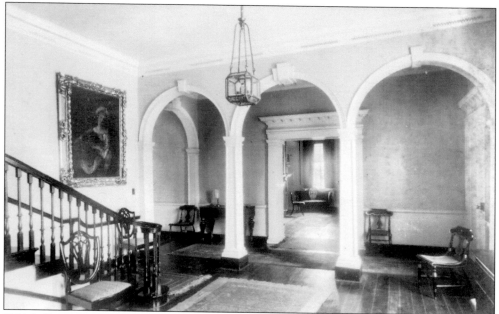

Widehall was purchased in 1909 by Mr. and Mrs. Wilbur W. Hubbard and extensively improved in 1911. They left the house to their son, Wilbur Ross Hubbard, who died in December 1993. Shown in this postcard is the main entry hall at Widehall, which extends the width of the house and continues through triple arches to a central hall and staircase. Widehall takes its name from the large space allotted for the hall and staircase on the street side of the house.

W. S. and A. M. Culp, Lumber, Builders' Supplies, Mill Work, Coal, Etc. was located on High Street between the railroad tracks and Lynchburg Street in Chestertown. A 1903 Sanborn Insurance Map noted this was a sash and door factory and had four saws, two planers, one mortiser, and lathe all on the first floor with an office, lathe scroll, and saw on the second floor. This postcard was postmarked from Chestertown, Maryland.

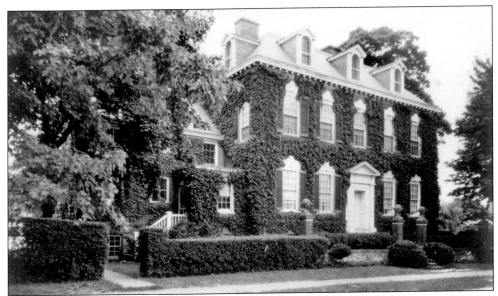

This view of Widehall is from Chestertown's historic Water Street. Wealthy merchant Thomas Smythe had this street entrance built with a terrace. The house was gutted; all mechanical, electrical, and HVAC systems were reworked; the balustrade and deck on the roof, as designed by architect Howard Sill in 1911, were installed; and all the interior finishes were redone and completed in 2002.

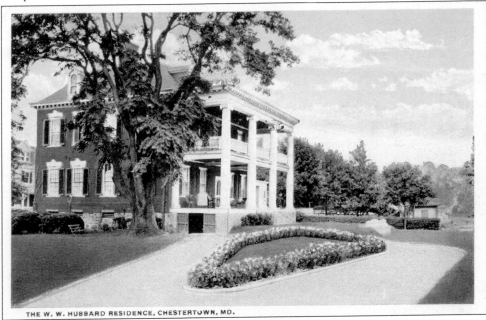

THE W. W. HUBBARD RESIDENCE, CHESTERTOWN, MD.

Widehall in Chestertown is known for its double-tiered porches and its gracious lawn to the Chester River. Its owners included Thomas Smythe, one of the wealthiest men of his time, Robert Wright, a U.S. senator and Maryland governor; and Ezekiel Forman Chambers, a U. S. senator, chief judge of the then (1826-1834) Second Judicial District of Maryland, and judge of the Court of Appeals of Maryland. At the time this postcard was published by Louis Kaufmann and Sons from Baltimore, Maryland, it was the W. W. Hubbard residence.

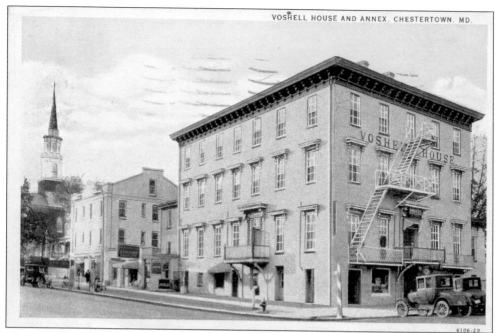

The Voshell House in downtown Chestertown is seen with the Annex to its left, which housed the Kent County Health Department in 1926 and then the office of Dr. George H. Dana, dentist. A Standard Gas Station can be seen to the left of the Voshell House. The postcard was postmarked August 28, 1939, Chestertown, Maryland, and was published by C. T. American Art Colored.

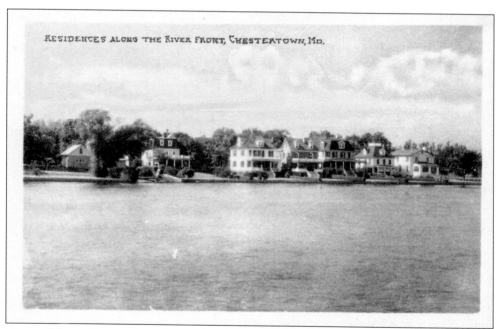

Many of the residences along the northern riverfront in Chestertown's historic district remain today, and the view from the Chester River Bridge is very much the same today as it was in this postcard published by Louis Kaufmann and Sons, Baltimore, Maryland.

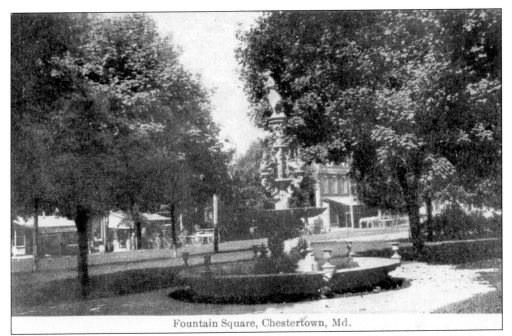

Fountain Square, Chestertown, Md.

This is Fountain Square, Chestertown, where Hebe, goddess of youth and beauty, cupbearer to the gods, still looks gracefully down on the park that was created many years ago by the Ladies Improvement Society. Fountain Park today is cared for by the Chestertown Garden Club, who oversaw the restoration of the fountain in early 1993.

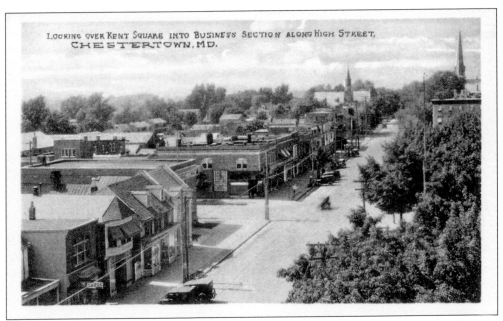

Looking over Kent Square into Business Section along High Street, CHESTERTOWN, MD.

This postcard view is looking over Kent Square into the business section along High Street in downtown Chestertown. Many of these buildings exist today with different facades. It was published by Louis Kaufmann and Sons, Baltimore, Maryland.

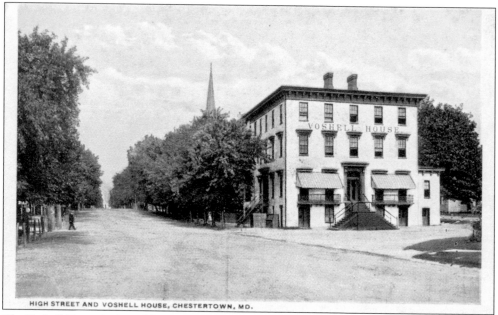

HIGH STREET AND VOSHELL HOUSE, CHESTERTOWN, MD.

The Voshell House is viewed from High Street in downtown Chestertown. It was opened in 1864 and cost $28,000 to build. C. T. Ringgold was the contractor. The building was demolished to make room for the new main office building of the Peoples Bank of Kent County, Maryland. The postcard was published by Louis Kaufmann and Sons, Baltimore, Maryland, and was made in the United States using C. T. American Art.

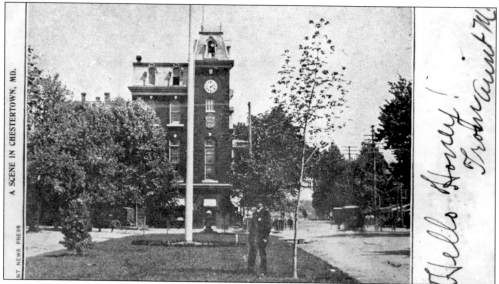

Stam Hall, *c.* 1886, located on the corner of High Street and Court Street in downtown Chestertown, is prominently seen from Monument Park. It was built at a cost of $15,000 for Colin F. Stam. The clock in its tower is considered the "town clock" as it was placed there by subscription from the citizens of the town at a cost of $800. During its history, the building has housed Chestertown's post office, the Lyceum Theatre, Stam's Drug Store, Chester Masonic Lodge 115, and a number of businesses. This postcard was published by the Kent News Press and was postmarked on September 25, 1905.

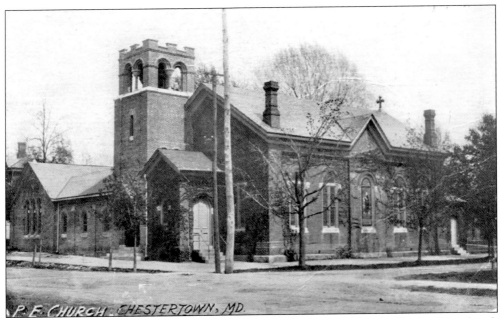

Emmanuel P. E. Church is located in the heart of Chestertown's historic district. The church was founded in 1707 and was the scene of the first convention, which proposed and adopted the name "Protestant Episcopal Church" in 1780. The card is postmarked in Chestertown in 1912 and was published by Louis Kaufmann and Sons in Baltimore, Maryland, series 114.

The Foxley Manor Motel, on Washington Avenue Extended, north of downtown Chestertown, is located within walking distance to Washington College. "Accommodations include a swimming pool, air conditioning and color television," the postcard notes. The motel operates today as the Driftwood Inn. The card was distributed by HPS, Inc., of Dover, Delaware, and published by Dynacolor Graphics, Inc., Miami, Florida.

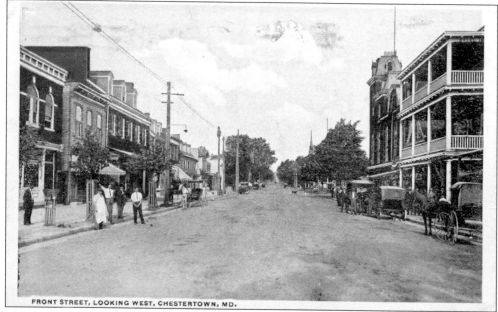

FRONT STREET, LOOKING WEST, CHESTERTOWN, MD.

This view of High Street in downtown Chestertown shows both the Imperial Hotel and Stam Hall on the left. Both buildings remain in existence today. The streetscape is much the same today as it is pictured. The postcard was published by Louis Kaufmann and Sons, Baltimore, Maryland, publishers of local views, and marked "Made in the U.S.A."

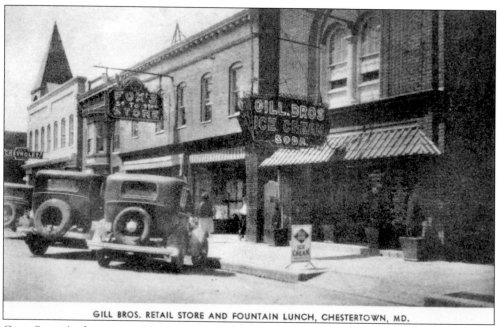

GILL BROS. RETAIL STORE AND FOUNTAIN LUNCH, CHESTERTOWN, MD.

Cross Street in downtown Chestertown was home to Gill Brothers Ice Cream and Soda store as well as Gill Brothers Ice Cream Factory and Dairy (Twigs and Teacups occupies the former Gill Brothers Factory building). A popular store in downtown Chestertown was Fox's 5¢ to $1 store, which is shown here on Cross Street. Fox's later moved to High Street and a much larger building. This limited-edition postcard was printed by S and W Printing, Centreville, Maryland.

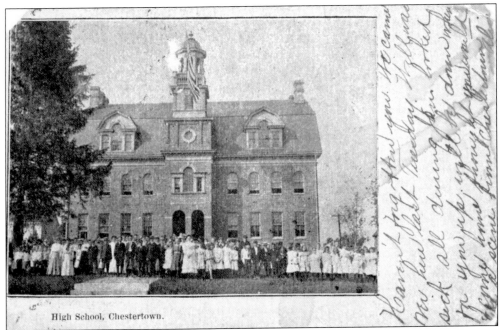

High School, Chestertown.

Called the "High School" in this postcard, this building is located at 400 High Street near downtown Chestertown. It is currently being used as the Kent County Government Office Building with offices for Kent County Planning and Zoning, the Kent County Treasurer's Office, the Kent County Tourism Office, Kent County Commissioners with their meeting room, and more.

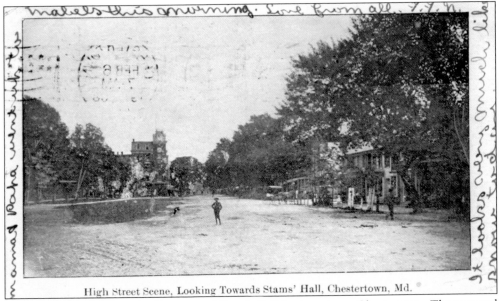

High Street Scene, Looking Towards Stams' Hall, Chestertown, Md.

This High Street scene is looking toward Stam's Hall in downtown Chestertown. The postcard was double-postmarked 1908 at Chestertown and Washington, D.C. The park on the left is Chestertown's Memorial Park. Businesses of the day are on the right of the tree-lined street, which ends at the Chester River.

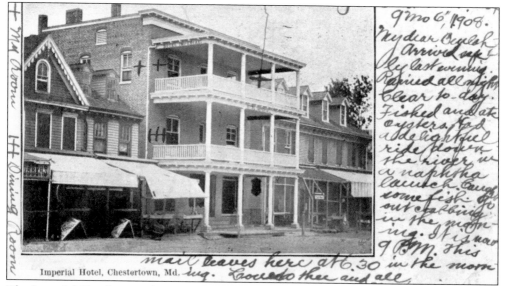

The Imperial Hotel on High Street in downtown Chestertown was built in 1903 by Wilbur W. Hubbard of Chestertown. The porches remain today, giving views of High Street and glimpses of the Chester River. The building was placed on the National Register of Historic Places in 1984. It is open today, offering lodging and dining. The card is postmarked 1908 from Chestertown, Maryland.

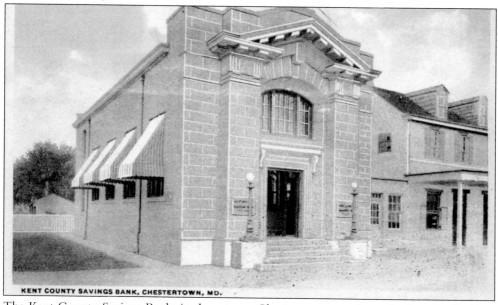

KENT COUNTY SAVINGS BANK, CHESTERTOWN, MD.

The Kent County Savings Bank, in downtown Chestertown, was located where Paul's Shoe Store is today. An advertisement placed in the *Kent News* on January 11, 1913, says, "The ample facilities of this safe, sound and strong institution, together with the progressive policy of its management, makes The Kent County Savings Bank an influential factor in the commercial life of Kent County, and those not having an account here are cordially invited to avail themselves of its services." M. A. Toulson was president; Fred. G. Usilton, vice president; and Wm. F. Russell, cashier. This postcard was published by Louis Kaufmann and Sons, Baltimore, Maryland, publishers of local views and was "Made in the U.S.A."

24

Kent Square in Chestertown shows Fountain Park as well as Memorial Park. Emmanuel Episcopal Church is seen on the left, and Stam's Hall is seen facing the parks. The card was postmarked from Peoria, Illinois.

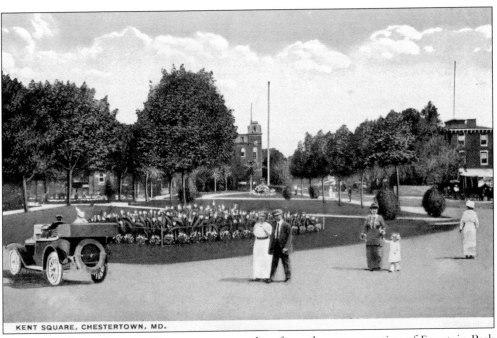

KENT SQUARE, CHESTERTOWN, MD.

This view of Kent Square, Chestertown, was taken from the upper portion of Fountain Park and includes Memorial Park and an imposing view of Stam Hall. The postcard was published by Louis Kaufmann and Sons, Baltimore, Maryland, and was postmarked from Chestertown, Maryland. It was made in the United States.

25

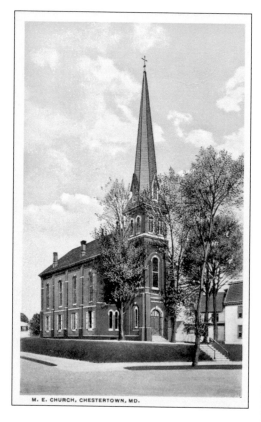

M. E. CHURCH, CHESTERTOWN, MD.

The First Methodist (M.E.) Church was established in Chestertown on May 5, 1780. Kent County had the first-organized unit of Methodism between the Chesapeake and Delaware Bays. The church was remodeled in 1928, and only the four walls and steeple were left virtually untouched when the job was complete. The postcard was published by Louis Kaufmann and Sons, Baltimore, Maryland, and made in the United States.

The Methodist Protestant Church in Chestertown is located on High Street and is now called Christ United Methodist Church. The church building is considered the most impressive Gothic Revival structure in Kent County. It was completed and dedicated in 1888. Benjamin Owens, a Baltimore architect, is reputed to have designed the church, and Milton Banker of Chestertown was the contractor. The 1900s brought an increase in membership to the church largely due to the Sunday school and group life. These groups offered its members both evangelistic witness and nourishment in Christian discipleship. This postcard was published by Louis Kaufmann and Sons, Baltimore, Maryland, and was made in the United States.

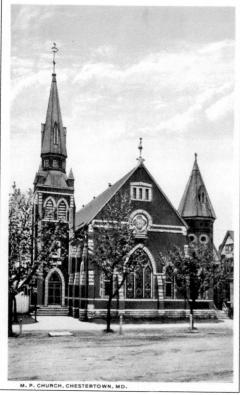

M. P. CHURCH, CHESTERTOWN, MD.

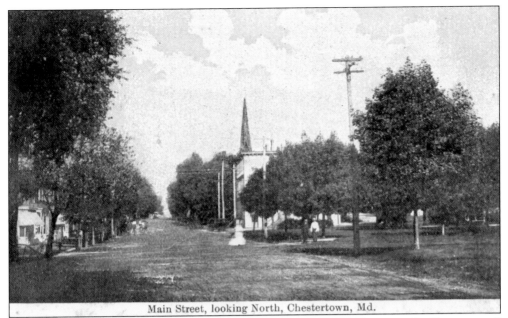

Main Street, looking North, Chestertown, Md.

This postcard has printed on its front that this view is "Main Street, looking North, Chestertown." The view is of High Street and shows the Voshell House and the First Methodist Church steeple. The message written on the back is dated October 14, 1911.

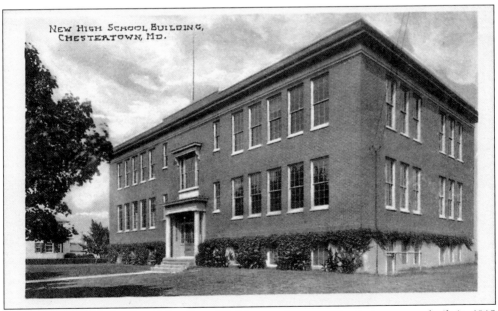

NEW HIGH SCHOOL BUILDING, CHESTERTOWN, MD.

This "New High School Building," on Washington Avenue, Chestertown, was built in 1915 at a cost of $3,700 for the lot and $16,800 for the building. A. M. Culp was the contractor and builder. Prof. Mark Creasy was the principal, and there were approximately 120 students. This postcard was published by Louis Kaufmann and Sons in Baltimore, Maryland.

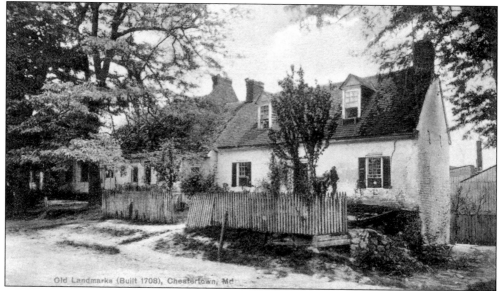

Old Landmarks (Built 1708), Chestertown, Md

The front of this postcard says "Old Landmarks (built 1708), Chestertown." One of the oldest landmark residences in Chestertown is the John Palmer House, which is also referred to as the Rock of Ages house. It is reputed that the stone for the Rock of Ages house was brought to Chestertown as ships' ballast by Capt. John Palmer, who erected it in the early 18th century. An engraving of this house is on the Kent County contribution to the silver service presented to the battleship *Maryland*. This postcard was published by M. A. Toulson, Apothecary, Chestertown, Maryland, and postmarked May 30, 1911, from Upper Falls, Maryland. Other markings on the card include: "Newvochrome A.N.C., NY, Leipzig, Dresden, Berlin, made in Germany."

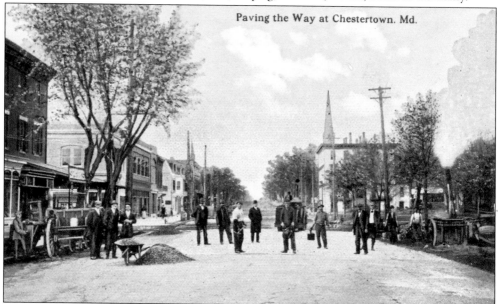

Paving the Way at Chestertown. Md.

This postcard is titled: "Paving the way at Chestertown on High Street looking west." The former Bordley's Corner is visible on the left, the Voshell House can be seen on the right, and the steeple of the First Methodist Church is prominent. The card was published by Louis Kaufmann and Sons, Baltimore, Maryland, and made in the United States.

28

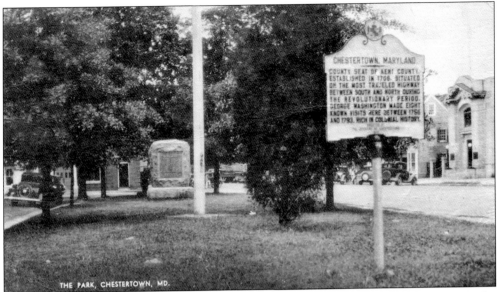

The Park in Chestertown is now referred to as Memorial Park or Monument Park. Among the monuments in the park are ones that honor the soldiers who fought in the War of 1812, the soldiers of Kent County Federal Army 1861–1865, the Colored Troops of Kent County in the Civil War, Confederate troops, World War I, World War II, the Korean War, Vietnam, and Desert Storm. The roadside marker in the foreground reads: "Chestertown, Maryland—County seat of Kent County. Established in 1706. Situated on the most traveled highway between south and north. During the Revolutionary period George Washington made eight known visits here between 1756 and 1793. Rich in colonial history. The Citizens of Chestertown—1932." The postcard was published by the Mayrose Company, Publishers, New York.

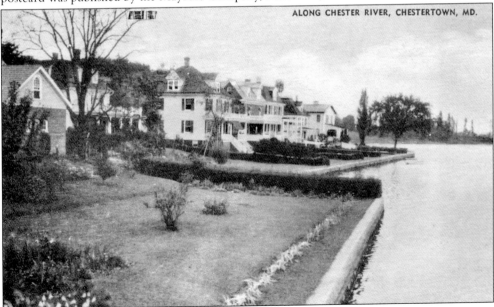

This view of North Water Street, Chestertown, along the Chester River, is much the same today. These homes have been restored over the past few years. The postcard was published by Art Photo Greeting Company, Elizabeth, New Jersey.

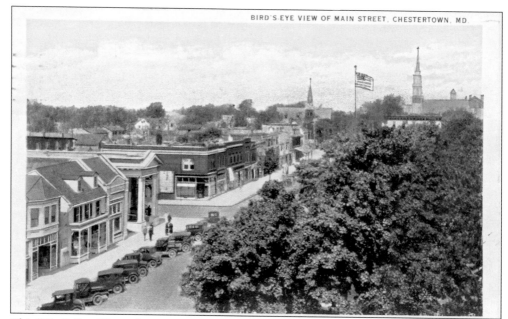

This "Bird's Eye View of Main Street, Chestertown" is looking west toward upper High Street. The former Bordley's Corner is prominent, and many of the buildings that can be seen are in existence today. Postmarked 1934, Chestertown, Maryland, this postcard is marked "C. T. American Art Colored" and published by TC Company, Chicago.

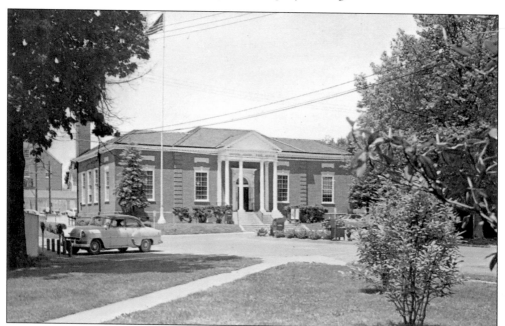

This U.S. Post Office on the corner of Calvert Street and Spring Avenue in downtown Chestertown was built in 1935 on the former site of the Bibb's Inn. The Post Office Department entered into negotiations with Thomas W. Eliason Jr. for the purchase of the Bibbs Inn. It was reported that 600 citizens signed a petition in favor of this new location. This postcard was published by David Traub at 2313 South Road in Baltimore, Maryland.

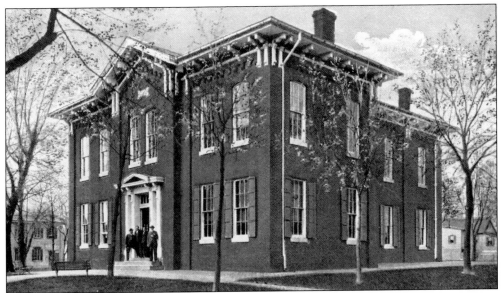

The Kent County Court House in Chestertown, shown here facing Memorial Park, was built in 1860. The original courthouse is no longer standing. It was built on this location between 1698 and 1707. An addition to the courthouse, built in the Georgian style, was dedicated in 1968. Kent County is fortunate to have many of its early records still surviving. Postmarked 1915 in Chestertown, Maryland, this postcard was published by Louis Kaufmann and Sons, Baltimore, Maryland, and made in the United States using C. T. American Art.

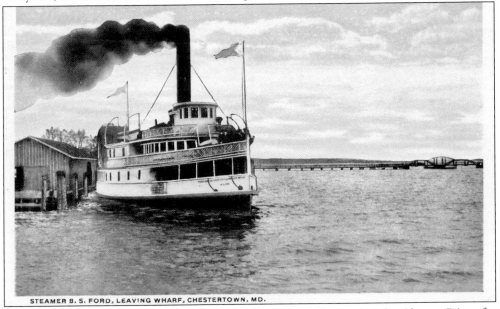

STEAMER B. S. FORD, LEAVING WHARF, CHESTERTOWN, MD.

The steamer *B. S. Ford* leaves the wharf in Chestertown. It traveled the Chester River for 46 years. Built in 1877, she burned in 1884 alongside the wharf in Chestertown. It is said her watch was too absorbed in playing cards to notice the flames. She was rebuilt after the fire and steamed on for another 39 years. This card was published by Louis Kaufmann and Sons, publisher of local views in Baltimore, Maryland, and made in the United States using C. T. American Art with the number A-55381.

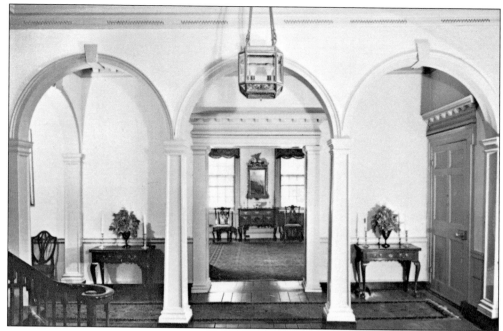

This interior view of Widehall, Chestertown, is from the hall looking through arches into the drawing room. Widehall was built in 1769 and remains today.

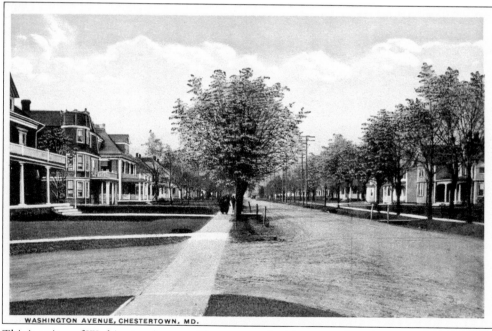

WASHINGTON AVENUE, CHESTERTOWN, MD.

This is a view of Washington Avenue, Chestertown, looking toward Washington College. These same houses can be seen along this street today. This postcard was published by Louis Kaufmann and Sons of Baltimore, Maryland, publishers of local views. It was made in the United States using C. T. American Art.

Two

WASHINGTON COLLEGE

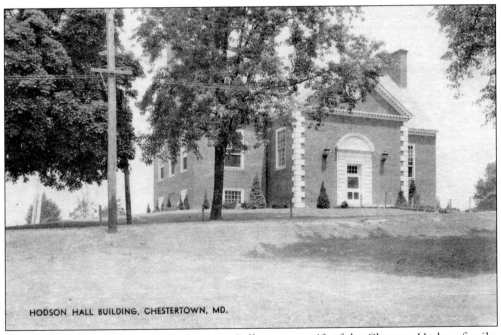

HODSON HALL BUILDING, CHESTERTOWN, MD.

The Hodson Hall building at Washington College was a gift of the Clarence Hodson family. The original building houses a dining hall, a lounge, and a snack bar. An addition was added in 1963 and included a new dining room, large lounge, new snack bar, modern bookstore, and a basement area improved to provide facilities for student activities. This card was postmarked June 27, 1941, and was published by Art Photo Greeting Company in Elizabeth, New Jersey.

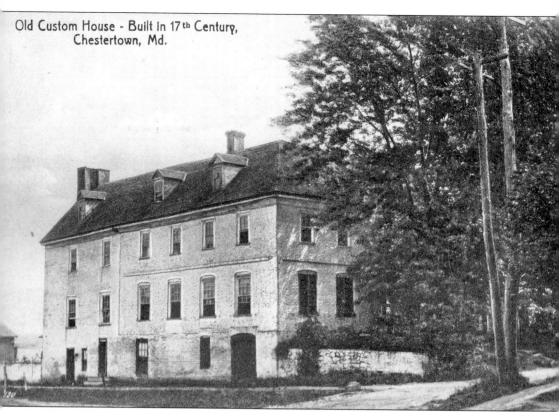

Old Custom House - Built In 17th Century,
Chestertown, Md.

The old Custom House at the end of High Street on the Chester River was built in the 17th century. It is pictured here in 1909 when it was purchased by W. W. Hubbard from Mary E. Brown. It was bequeathed to Washington College by Wilbur Ross Hubbard, who died in 1993. The Custom House is recognized on the National Register of Historic Places. Today the Custom House is home to the C. V. Starr Center for the Study of the American Experience, the Center for the Environment and Society, and the Washington College Archaeology Lab. This postcard was published by J. C. Rote, Chestertown, Maryland, and was made in Germany.

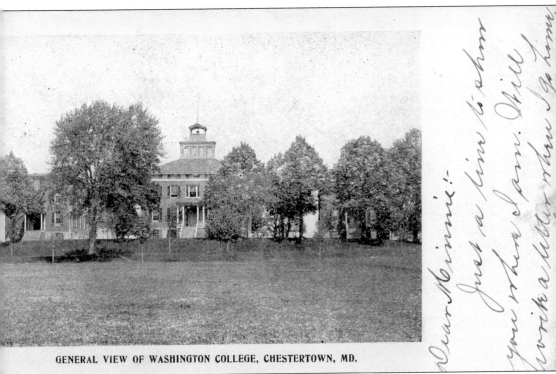

GENERAL VIEW OF WASHINGTON COLLEGE, CHESTERTOWN, MD.

This was a general view of Washington College during the time when Dr. James W. Cain was president (1903–1918). When Dr. Cain arrived, the college consisted of 121 students, 6 professors, West Hall, Middle Hall, East Hall, and Reid Hall (then known as Normal Hall), a small frame gymnasium, three professors' houses, and a windmill. This postcard was postmarked from Chestertown on June 27, 1908.

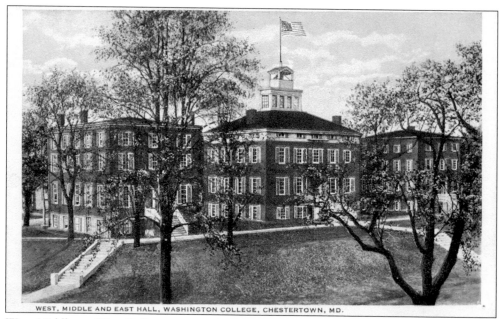

WEST, MIDDLE AND EAST HALL, WASHINGTON COLLEGE, CHESTERTOWN, MD.

West, Middle, and East Halls are now used as dormitories at Washington College. Middle Hall is the oldest standing structure on the college campus. East Hall at one time served as the residence for the college president and vice president. This postcard was published by Louis Kaufmann and Sons, Baltimore, Maryland, and made in the United States.

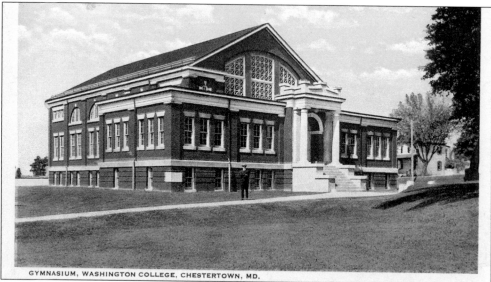

GYMNASIUM, WASHINGTON COLLEGE, CHESTERTOWN, MD.

Cain Gymnasium, part of Washington College, was built in 1913 and named after Washington College president Dr. James W. Cain, who served as the president of Washington College for 15 years. The college honored Dr. Cain in 1937 by naming the gymnasium, built during his administration, the James W. Cain Gymnasium. Cain Gymnasium was demolished in the late 1960s to make room for a new College Library. In 1968, when the athletic facilities were enlarged, those facilities were named the James W. Cain Athletic Center as further tribute to Dr. Cain. This postcard was published by Louis Kaufmann and Sons, Baltimore, Maryland, and was made in the United States using C. T. American Art.

36

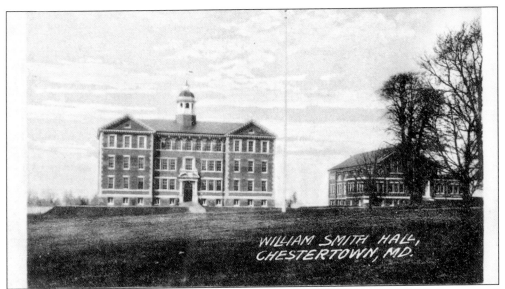

William Smith Hall and Cain Gymnasium at Washington College are shown on the postcard marked "C. T. American Art Colored." Cain Gymnasium no longer exists. William Smith Hall was named after Washington College's founding president, Dr. William Smith. Dr. Smith arrived on campus in 1780. He was a noted preacher, educator, and land speculator. The original William Smith Hall was built in 1907 and destroyed by fire in 1916. It was rebuilt by 1918, and the new building had two new features, a cupola on top and two vaults for the protection of valuable documents.

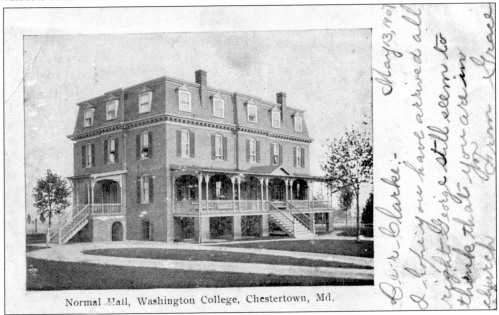

Normal Hall, Washington College, Chestertown, Md.

Normal Hall was erected in 1896 to house the College Normal Department when the state approved a program for women. The Normal Department was abandoned in 1910, and the structure became a women's dormitory named Reid Hall after college president Charles W. Reid. The dormitory was remodeled in 1929 and subsequently underwent an architectural makeover to reflect the Colonial style of Mount Vernon. The postcard is dated May 13, 1907.

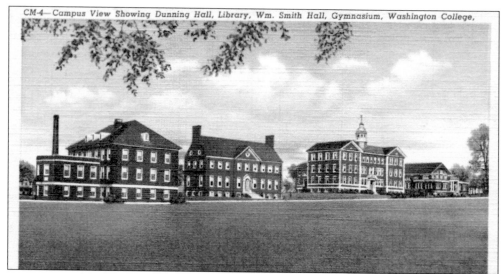

This postcard of the "Campus View Showing Dunning Hall, Library, Wm. Smith Hall, Gymnasium, Washington College," was addressed to the *Stop the Music* television show in New York City. It was from Virginia S. Wern of Worton, Maryland, and postmarked from Worton. The card states, "Washington College, Founded 1782. George Washington gave its founding, granting use of its name and served on board of its visitors and governors. He attended public exercises here in 1784 and received Degree of Doctor of Law in 1789." The Harry P. Cann and Brothers Company of Baltimore published the card marked "Genuine Curteich-Chicago, C. T. Art-Colortone."

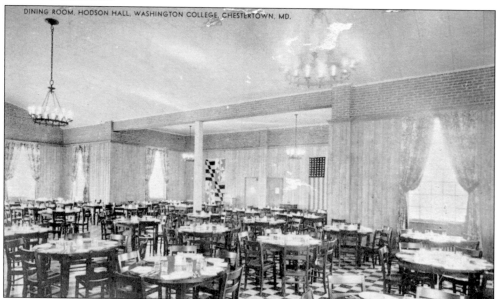

DINING ROOM, HODSON HALL, WASHINGTON COLLEGE, CHESTERTOWN, MD.

The dining room in Hodson Hall at Washington College is shown in this postcard published by Art Photo Greeting Company, Elizabeth, New Jersey. Hodson Hall was named as a memorial to Clarence Hodson, who was appointed a member of the Washington College Board of Visitors and Governors in 1922. In 1936, the Hodson Trust funded the construction of Hodson Hall as well as the 1964 addition that provided space for a new dining room, snack bar, bookstore, and student lounge.

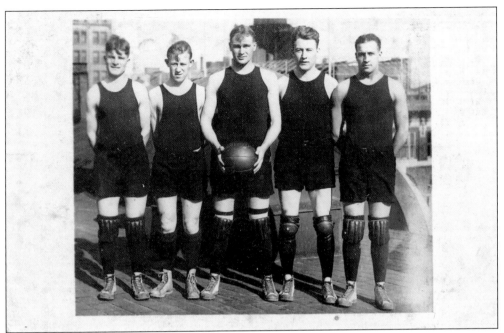

The Washington College Basketball Team was state champion in 1923. Team members included, from left to right, Carrington, Dumschott, Gordy (captain), Carroll, and Fiore. Basketball, as an intercollegiate sport, did not develop at Washington College until after 1913 and the erection of Cain Gymnasium. By the 1916–1917 season, the college team was considered an outstanding team among Maryland colleges. This postcard was published by Grogan Photo System, Inc., Milwaukee, Wisconsin.

WASHINGTON COLLEGE BASKETBALL TEAM
STATE CHAMPIONS 1923

W. C.		Opp.
31 U. S. Naval Academy	.	38
33 U. S. Marines	.	22
27 Washington and Lee	.	18
26 V. M. I.	.	15
28 V. P. I.	.	20
27 Catholic University	.	25
26 Loyola	.	21
47 Wilmington K. C.	.	27
29 Mount St. Mary's	.	16
28 St John's	.	12
19 Dickinson	.	12
42 Alumni	.	10
31 Mount St Mary's	.	22
37 U S Marines	.	24
48 Temple University	.	26
33 University Penn, Jr	.	7
40 P M C.	.	41
22 St John's	.	13
39 Blue Ridge	.	17
37 Loyola	.	12
31 Y. M H A.	.	26
32 Kent All-Stars	.	17
37 Eastern Shore Stars	.	18

Team, left to right—Carrington, Dumschott, Gordy (Capt.), Carroll, Fiore.

Post Card

WASHINGTON COLLEGE
CHESTERTOWN MD.

1. The oldest College in the State.
2. Fifteen units required for admission.
3. A standard four-year curriculum leading to the A B. and B. S. degrees.
4. An accredited Department of Education.
5. Coeducation.
6. Free tuition to Maryland Students.
7. Expenses, not including tuition, slightly in excess of $315 a year.

This postcard lists the Washington College basketball team's opponents and scores in 1923 when they were the state champions.

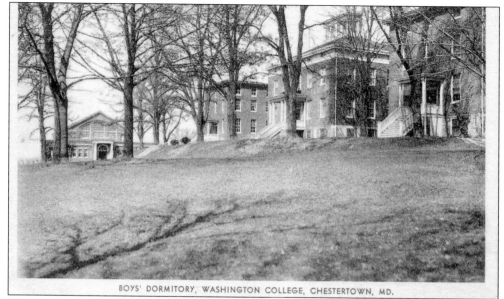

BOYS' DORMITORY, WASHINGTON COLLEGE, CHESTERTOWN, MD.

The boys' dormitories at Washington College included East, Middle, and West Halls. The now-demolished Cain Gymnasium can be seen on the far left in the back. In 1923, Washington College advertised it was the oldest college in the state; required 15 units for admission; offered a standard four-year curriculum leading to the A.B. or B.S. degrees; had an accredited department of education school; was coeducational; offered free tuition to Maryland students; and that expenses, not including tuition, were slightly in excess of $315 a year. This postcard is an "Art Postcard" by Art Photo, Elizabeth, New Jersey.

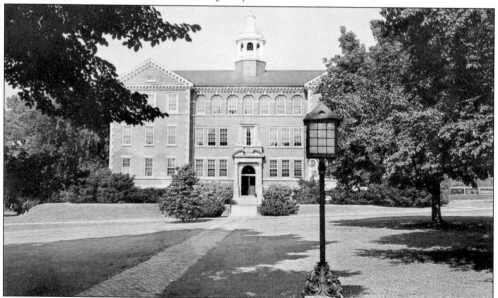

William Smith Hall, the administration building on the Washington College campus, is often used on postcards. This card was sent and signed by Bedford Groves, who worked at the college at the time. His message read, "With best wishes from The Alumni Association—and with found hopes that one day the New Arrival will enter these portals!!" The card features "Kolorvue" by Artvue Postcard Company, 225 Fifth Avenue, New York.

The Frank Russell Gymnasium at Washington College was opened in 1956 and was marked by the return of varsity basketball since the beginning of the sport in the 1912–1913 season. The Maryland General Assembly appropriated $250,000 for the new building. This card was published in "Kolorvue" by Artvue Postcard Company, 225 Fifth Avenue, New York.

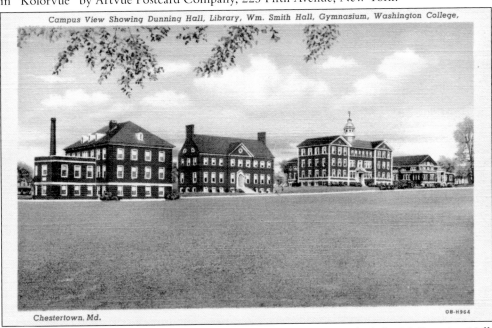

Campus View Showing Dunning Hall, Library, Wm. Smith Hall, Gymnasium, Washington College,

Chestertown, Md.

OB-H964

This postcard shows the Washington College campus beginning on the left with Dunning Hall, which was also known as the science building; followed by the library, which now serves as administration offices; William Smith Hall, which remains today with classrooms and a theater; and Cain Gymnasium, which was demolished to make way for a new library. The view of the campus is from Washington Avenue, Chestertown.

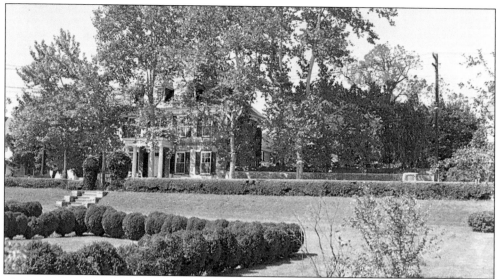

The Hynson-Ringgold House, located with views of the Chester River in the historic district of Chestertown, was built in 1735 by Thomas Ringgold. It was acquired by Washington College in 1944 and has served as the residence for the college president and his family since 1946. One of the most distinguishing interior features of the Hynson-Ringgold House is the "antler" staircase, hand-carved from walnut under the direction of architect William Buckland. The original paneling from the drawing room is now in the Chestertown Room of the Baltimore Museum of Art. This postcard was published in "Kolorvue" by Artvue Postcard Company, 225 Fifth Avenue, New York.

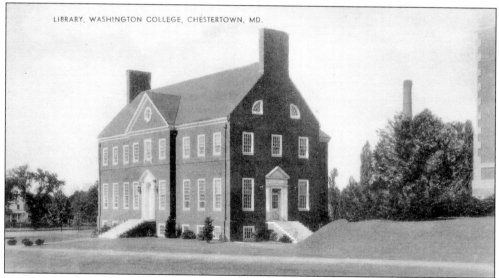

Bunting Library at Washington College was a gift of Dr. George Avery Bunting, who graduated from the college in 1891 and developed Noxema skin cream in 1914. He was secretary of the Board of Visitors and Governors at the time of his death in 1959. The library was dedicated on February 24, 1940. Bunting Library existed until the opening of the Clifton M. Miller Library in 1971 where Cain Gymnasium once stood. Bunting Library became Bunting Hall and continues to house offices of the college administration. This card was published by the Mayrose Company Publishers in Linden, New Jersey.

42

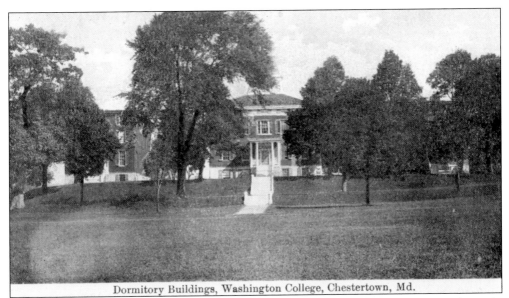

Dormitory Buildings, Washington College, Chestertown, Md.

The dormitory buildings "on the hill" at Washington College shown on this postcard remain today and are listed on the National Register of Historic Places. Washington College began construction of its first building, named Common Building, in 1783. It was completed in 1789 and was destroyed by fire on January 11, 1827. Middle Hall (1844) and East and West Halls (1854) hold a special place in the history of Washington College in that they are the oldest surviving campus buildings and serve as monuments to the original Common Building, whose site they occupy.

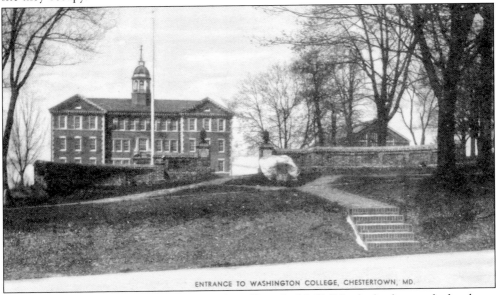

ENTRANCE TO WASHINGTON COLLEGE, CHESTERTOWN, MD.

This entrance to Washington College, with William Smith Hall in the background, also shows the tablet and stone memorializing the granting of the honorary degree of doctor of laws to George Washington in 1789. The stone is of native granite from the hills of Cecil County and was presented to the college on October 22, 1925, by the Old Kent Chapter of the Daughters of the American Revolution. This postcard was published by the Mayrose Company Publishers in Linden, New Jersey.

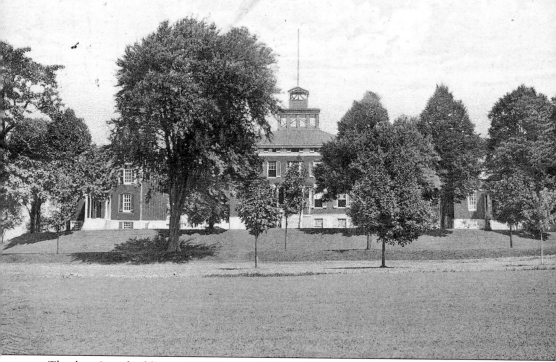

Dormitory Buildings, Washington College, Chestertown, Md.

The dormitory buildings at Washington College remain in existence today. It is the first college chartered in the new nation. George Washington gave the college 50 guineas, served on the Board of Visitors and Governors for five years until 1789 when he became president of the United States, and gave the college the use of his name. The middle building, or Middle Hall, is the oldest building on the college campus. This card was postmarked in Chestertown, Maryland, on June 1, 1908, and was made in Germany and published by J. H. Sides, jeweler, Chestertown.

Three

TOLCHESTER

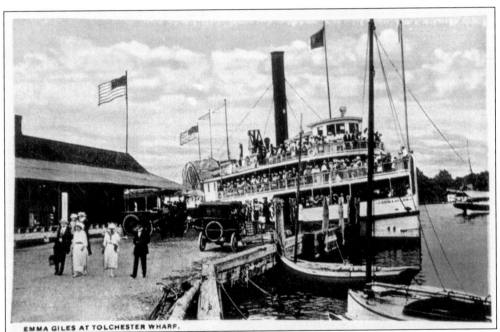

EMMA GILES AT TOLCHESTER WHARF.

The *Emma Giles* was a wooden side-wheel steamboat built for the Tolchester Steamboat Company by William E. Woodall and Company of Baltimore. It was launched in 1887. The Tolchester experience on the *Emma Giles* of the early 1900s meant many things to many people. By 1936, she had been modified to carry trucks and automobiles, and her wheelhouse had been moved aft with only a single cabin attached.

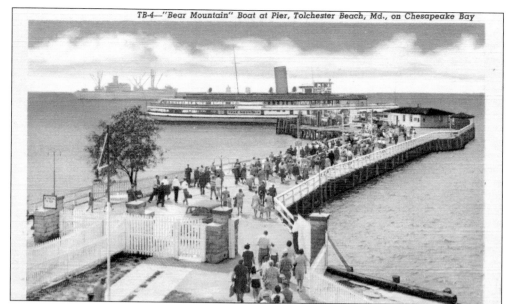

The *Bear Mountain* excursion steamer at the pier at Tolchester was acquired by B. B. Wills who had bought the Tolchester Line. In late 1943, Wills made arrangements to acquire *Bear Mountain*, a modernized and fast New York side-wheeler with a capacity of over 2,000 passengers. She began operating in 1944 and continued in the postwar summer season. Her last trip on September 19, 1948, ended her career in Baltimore. The postcard is marked "TB4—'Bear Mountain' Boat at Pier, Tolchester Beach, Md. on Chesapeake Bay." It was published by the Harry P. Cann and Brothers Company, Baltimore, Maryland, in genuine Curteich-Chicago with "C. T. Art-Colortone."

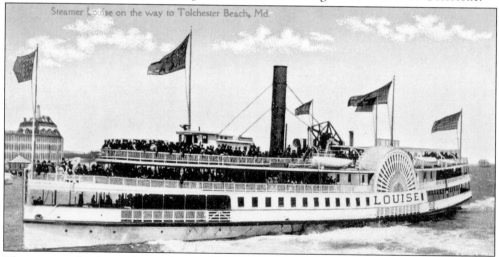

The steamer *Louise*, an iron side-wheel steamboat built by Harlan and Hollingsworth of Wilmington, Delaware, is shown here on its way to Tolchester Beach, Maryland. She came to the Tolchester Steamboat Company and the excursion trade in 1883 after a long career running the Gulf coast between New Orleans and Mobile. She served as transport during the Civil War and operated between Baltimore and the York River as an overnight packet. She was completely remodeled as an excursion boat and transported as many as 2,500 passengers to Tolchester Beach several times each day in the summer. This postcard was published by the Chessler Company, Baltimore, Maryland, and postmarked Tolchester Beach, Maryland, on July 30, 1915.

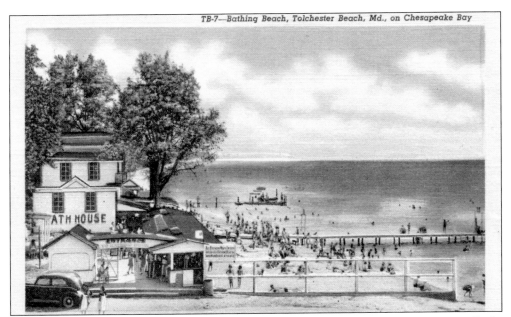

This bathing beach on the Chesapeake Bay at Tolchester Beach was a popular spot, especially for those who traveled by steamship from Baltimore to enjoy Tolchester's beach and amusements. In 1659, Cecilius Calvert, Lord Proprietor, had granted William Toulson a parcel of land known as Toulchester (later shortened to Tolchester). It has been presumed that the title was derived from the Toulson name and the neighboring Chester River, hence Tolchester. The postcard is marked "TB-7" and was published by the Harry P. Cann and Brothers Company, Baltimore, Maryland, and marked "Genuine Curteich-Chicago C. T. Art-Colortone."

Tolchester Beach closed in 1959, and the property was sold. Houses now sit atop the hill that once brought such joy to the young and old. The area where the bathing house once stood is now the Tolchester Marina. This card was postmarked from Tolchester Beach on August 27, 1909.

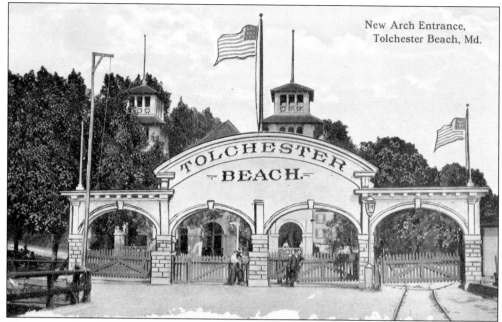

The new arch entrance is shown at Tolchester Beach, Maryland. This card was published by I and M Ottenheimer, Baltimore, Maryland, and made in United States. To send this card, it cost 1¢ for the United States and "Island Possessions" Cuba, Canada, and Mexico and 2¢ for foreign lands.

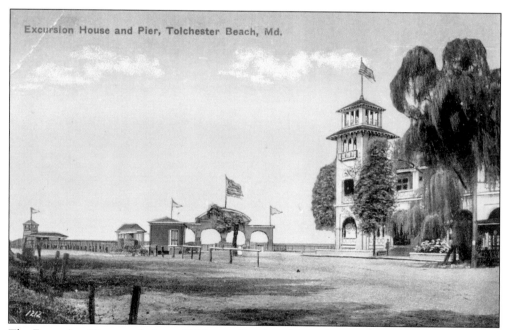

The Excursion House and pier at Tolchester Beach welcomed many visitors between 1877 and 1962. Tolchester Beach pennants, glassware, and other souvenirs were given away at the bingo-novelties booth. This card was published by the Chessler Company, Baltimore, Maryland.

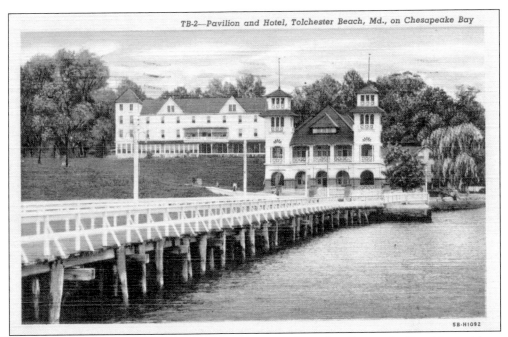

This card is of the pavilion and hotel at Tolchester Beach on the Chesapeake Bay. Many visitors to the amusement park enjoyed the Tolchester Carousel, which was said to be hand-powered during its earliest years. This postcard, No. TB-2, was postmarked Chestertown, Maryland, June 18, 1951. It was published by the Harry P. Cann and Brothers Company, Baltimore, Maryland, in genuine Curteich-Chicago "C. T. Art-Colortone."

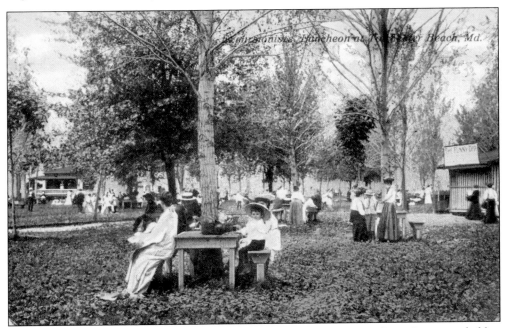

Excursionists enjoy lunch at Tolchester Beach. Many family picnics and reunions were held at Tolchester. This card was postmarked Baltimore, Maryland, on July 12, 1911, and was published by the Tolchester News Company, Baltimore.

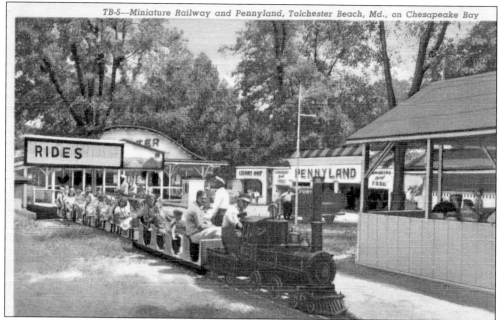

This card shows the miniature railway at Tolchester. A coal-fired steam engine pulled a 12-car train from the late 1880s to the final season of the park. This card, No. TB-5–5B–H1095, was published by the Harry P. Cann and Brothers Company, Baltimore, Maryland, in genuine Curteich-Chicago, "C. T. Art-Colortone."

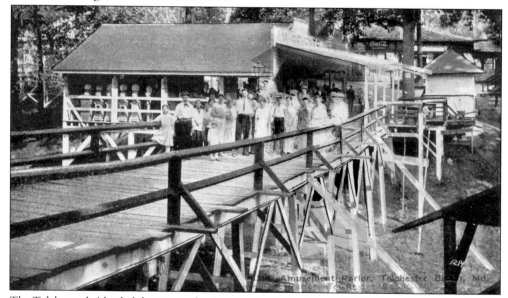

The Tolchester bridge led the way to the Amusement Parlor. By 1956, Tolchester Beach was bought by Wilson Lines, who sold its entire Tolchester holdings, including the *Bay Belle* steamship and the park, to a Baltimore company called the Wilson-Tolchester Company, an organization with no ties to either the old Tolchester Steamboat Company or the Wilson group. Tolchester Park was sold at auction in 1962 for $75,000, and one month later, the *Bay Belle* was sold at auction to Wilson Lines, Inc., and towed to Wilmington, Delaware. This postcard was published by the Chessler Company, Baltimore, Maryland.

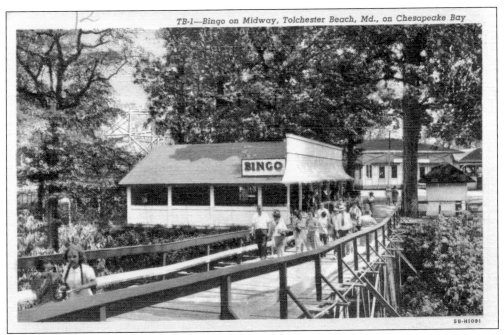

This postcard shows the bingo pavilion on the midway at Tolchester. This card, No. TB-1, was published by the Harry P. Cann and Brothers Company, Baltimore, Maryland, in genuine Curteich-Chicago, "C. T. Art-Colortone."

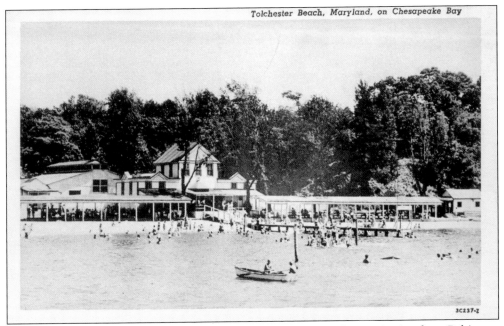

Tolchester Beach, Maryland, on Chesapeake Bay

Tolchester Beach, Maryland, on the Chesapeake Bay, welcomed excursionists from Baltimore who enjoyed a beachside restaurant with a second floor large enough for dances and banquets. This card was published by the Harry P. Cann and Brothers Company, Baltimore, Maryland, in genuine Curteich-Chicago "C. T. Photo-Finish."

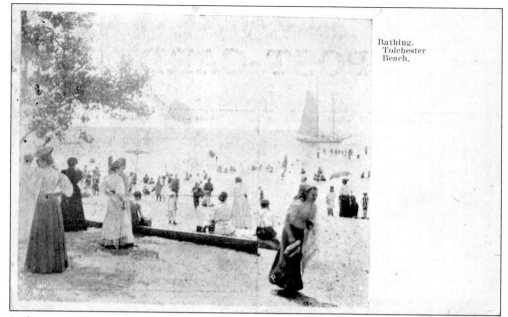

Bathing on the Chesapeake Bay was a popular pastime at Tolchester Beach in the early 18th century. Bathing suits could be rented. Ladies' bathing suits included a blouse and skirted bloomers and black stockings. Men's bathing suits were one-piece and knit. It is said that not many bathers swam. Most stayed in the shallow water and simply refreshed themselves.

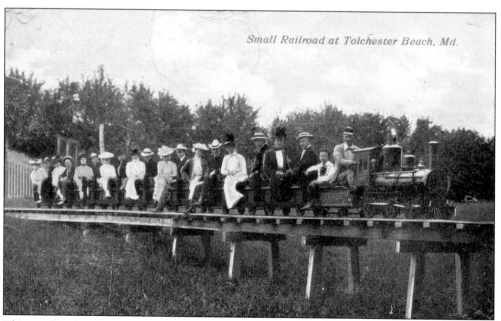

Small Railroad at Tolchester Beach, Md.

This small railroad at Tolchester Beach, Maryland, was loved by all ages. Miniature railroads are said to have been introduced at the Philadelphia Centennial in 1876. Postmarked Elkton, Maryland, August 9, 1910, this card was published by Tolchester News, Baltimore, Maryland.

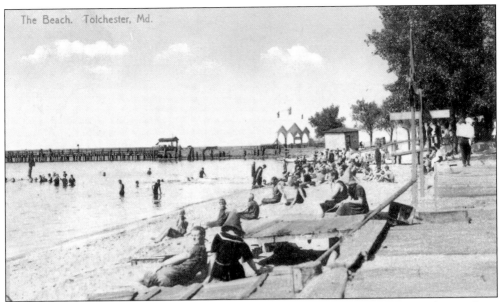

The beach at Tolchester welcomed scores of Baltimoreans over many years. Around 1857, Capt. William C. Eliason had an idea for a summer resort for Baltimoreans on Kent County's shore. Captain Eliason commanded a steamboat on the Delaware Bay at the time. On October 22, 1887, a Certificate of Incorporation of the Tolchester Beach Improvement Company of Kent County was filed. Postcard No. 26 was made in Germany and published by the Rinn Publishing Company. It was postmarked Tolchester Beach, Maryland, on July 24, 1910.

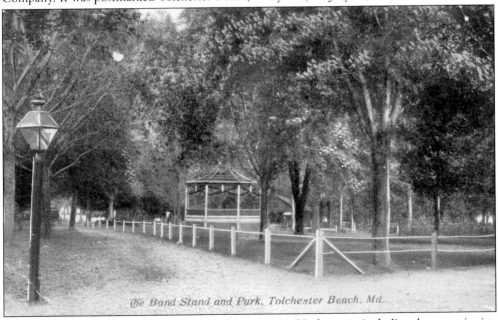

The Band Stand and Park at Tolchester Beach are memorable for many including the excursionists who came by steamboat across the Chesapeake Bay from the Western Shore of Maryland. The Band Stand is now on the grounds of the Chesapeake Bay Maritime Museum in St. Michaels, Maryland, where events are held in the summer. This card was published by Tolchester News Company, Baltimore, Maryland.

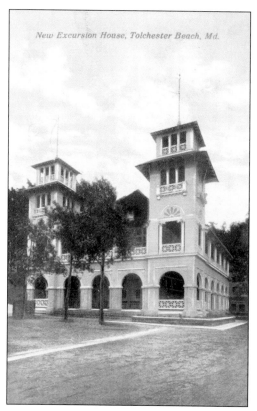

New Excursion House, Tolchester Beach, Md.

This is the new Excursion House at Tolchester Beach as it was in 1911. In 1899, four interlocking companies, the Tolchester Steamboat Company of Camden, New Jersey; the Tolchester Beach Improvement Company of Kent County; the Chesapeake Steamboat Company of Baltimore City; and the Port Deposit and Havre de Grace Steamboat Company of Baltimore City combined under one name—the Tolchester Beach Improvement Company. Purchase of the Sassafras River Steamboat Company the same year further enlarged the company, adding wharfs, an established route, and two steamboats, the *Sassafras* (renamed the *Annapolis*), and *Van Corlaer the Trumpeter* (renamed the *Kitty Knight*). This card was published by Tolchester News Company, Baltimore, Maryland, and is postmarked Tolchester Beach, Maryland, July 3, 1911.

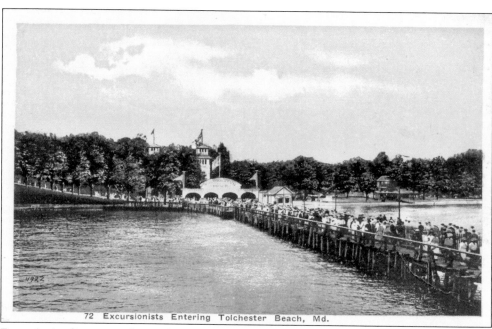

72 Excursionists Entering Tolchester Beach, Md.

Excursionists line up on the pier to enter Tolchester Beach. The main entryway was a landmark for the amusement park. It was renovated several times. This postcard, No. 72, was published by the Chessler Company in Baltimore, Maryland.

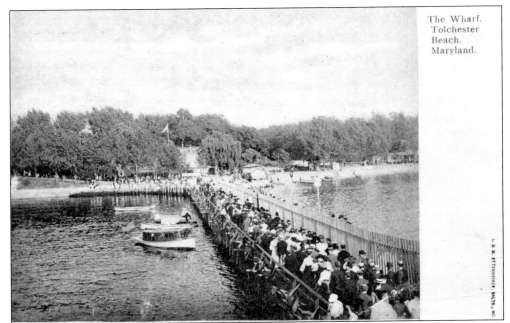

The Wharf. Tolchester Beach. Maryland.

This postcard shows the wharf at Tolchester Beach where passengers disembarked from the many steamboats, which used their excursion boats to capitalize on the people's interest in amusement parks. Tolchester started with a hotel, restaurant, bathhouses, some amusement park attractions, and picnic grounds. After completion of this first set of features, the resort was heavily advertised in Baltimore. The effort quickly paid off, and Tolchester Beach became a popular destination for Baltimoreans. This card was published by I and M Ottenheimer, Baltimore, Maryland.

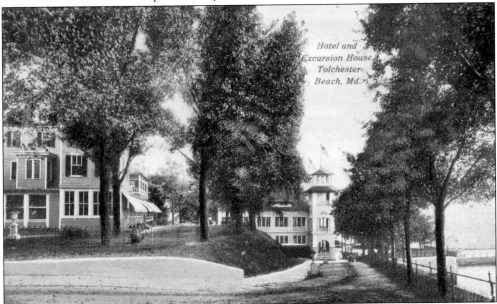

Hotel and Excursion House, Tolchester Beach, Md.

The Tolchester Hotel and Excursion House are shown as photographed by the Tolchester News Company of Baltimore. Many visitors came to Tolchester Beach and stayed at the Tolchester Hotel, which also served meals. The Excursion House was used by those who arrived by excursion boat to spend only the day. This card was postmarked Tolchester Beach, Maryland.

55

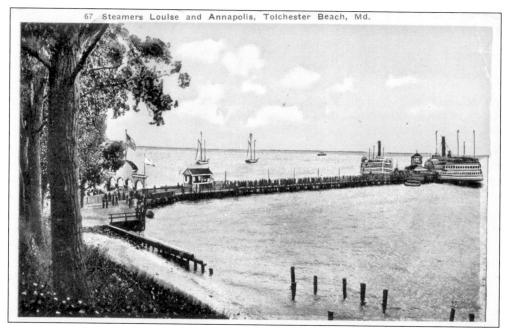

67 Steamers Louise and Annapolis, Tolchester Beach, Md.

The steamers *Louise* and *Annapolis* are docked at the end of the pier at Tolchester. The *Louise* was sold to the Tolchester Steamboat Company in 1883 and made runs to Tolchester until 1926, when it was sold to C. L. Dimon of New York. The *Annapolis* was transferred to the Tolchester Beach Improvement Company in 1899, burned in 1935, and was abandoned. This postcard was published by the Chessler Company, Baltimore, Maryland, and postmarked Tolchester Beach, Maryland, in August 1923.

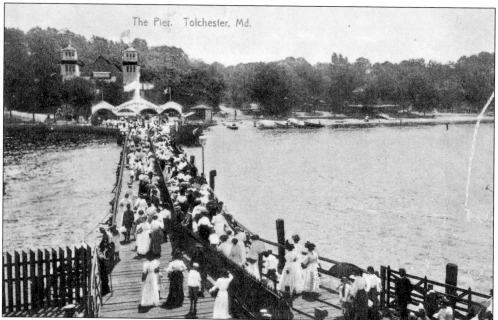

The Pier. Tolchester, Md.

The pier is shown at Tolchester as a large group disembarks from a steamer to enter the park area. This postcard was published by Rinn Publishing Company and made in Germany. It is postmarked Tolchester Beach, Maryland, August 26, 1910.

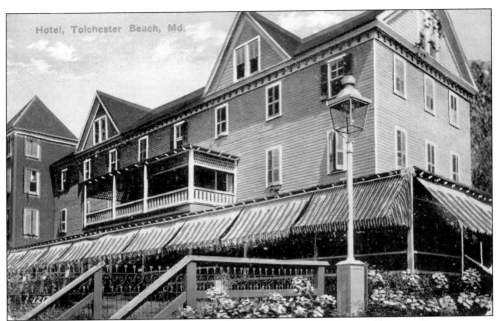

The Tolchester Beach Hotel was home to guests who came to enjoy the Kent County resort and beach on the Chesapeake Bay. A committee created by the Kent County Farm Bureau in 1965 took an option on the 53-acre property that included as many as 100 buildings of various types with 1,825 feet of waterfront on the Chesapeake Bay. The owners were asking $95,000 for the property. Apparently the people of Kent County at the time who were polled by Kent's Commissioners did not see the need for it to be purchased as a recreation area. This postcard was published by the Chessler Company, Baltimore, Maryland.

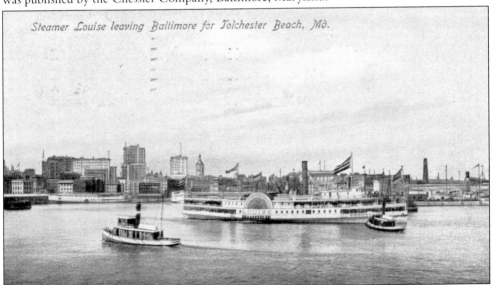

The steamer *Louise* leaves Baltimore for Tolchester Beach. Four classes of steamboats plied the Chesapeake Bay: double-ended ferryboats, overnight freight and passenger steamers, large packets, and excursion boats. Side-wheel propulsion was the dominant mode of propulsion for steamboats on the Chesapeake Bay. Postcard No. 120 was made in Germany and published by J. Thomas Smith, Baltimore, Maryland. It was postmarked Baltimore on July 10, 1911.

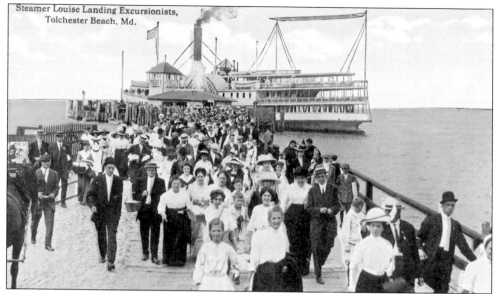

Steamer Louise Landing Excursionists, Tolchester Beach, Md.

The steamer *Louise* is landing excursionists at Tolchester Beach. Baltimoreans danced their way across the Chesapeake Bay onboard the *Louise* to Tolchester for 42 seasons. She was sold in 1926 to C. L. Dimon, New York, for runs from Bayonne, New Jersey, to Coney Island as *Express*. She sank off Manhattan Beach while under conversion into a floating restaurant. This postcard was made in the United States and published by I and M Ottenheimer, Baltimore, Maryland.

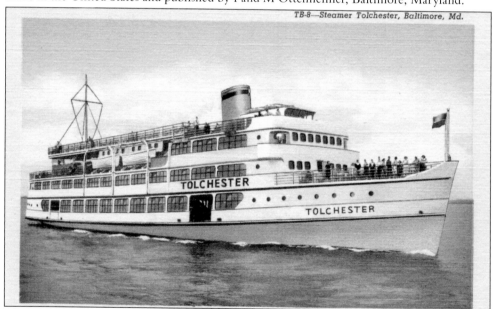

TB-8—Steamer Tolchester, Baltimore, Md.

The steamer *Tolchester*, the second, was an iron side-wheel steamboat built in 1878 by Harlan and Hollingsworth of Wilmington, Delaware. In 1918, while under naval service off Bridgeport, Connecticut, a beam went through the bottom. She was on the Chesapeake Bay under the Tolchester Company in 1933, burned in 1941, and was converted to a barge to haul pulpwood for the Chesapeake Corporation of Virginia. She was abandoned in South Norfolk, Virginia, in 1969. The postcard is TB-8, published by the Harry P. Cann and Brothers Company in Baltimore, Maryland.

STEAMER TOLCHESTER

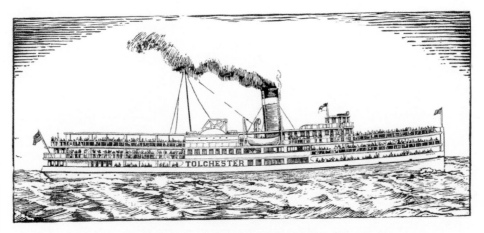

BALTIMORE'S LARGEST EXCURSION STEAMER

Steamer *Tolchester*, Baltimore's largest excursion steamer (the third), was a steel screw steamboat built in 1909 by Harlan and Hollingsworth of Wilmington, Delaware. She was launched in 1909 as *City of Philadelphia* along with sister ship *City of Washington* (later *Bay Belle*). By 1956, she was deemed unfit for service and sold to the Wills Development Corporation of Baltimore to be moored in gambling waters off non-gambling Virginia until Maryland outlawed gambling as well.

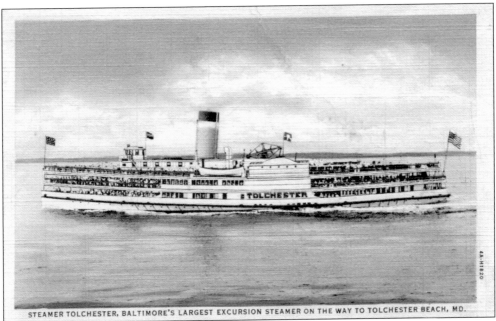

STEAMER TOLCHESTER, BALTIMORE'S LARGEST EXCURSION STEAMER ON THE WAY TO TOLCHESTER BEACH, MD.

Steamer *Tolchester* steams its way to Tolchester Beach. The steamboats and the park did not serve alcoholic beverages, and the Tolchester Company prohibited their consumption on its boats and property. This card was published by I and M Ottenheimer, Baltimore, Maryland in "C. T. Art-Colortone." It was postmarked Baltimore, Maryland, on November 2, 1940.

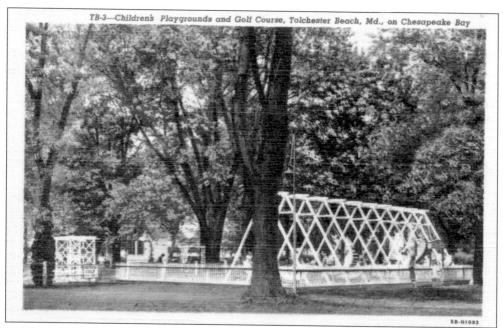

TB-3—Children's Playgrounds and Golf Course, Tolchester Beach, Md., on Chesapeake Bay

A children's playground and golf course were popular with visitors to Tolchester Beach, Maryland, on the Chesapeake Bay. The postcard was marked TB-3 and published by the Harry P. Cann and Brothers Company, Baltimore, Maryland. It was a "genuine Curteich-Chicago, C. T. Art-Colortone" card and postmarked Baltimore, Maryland, September 7, 1951.

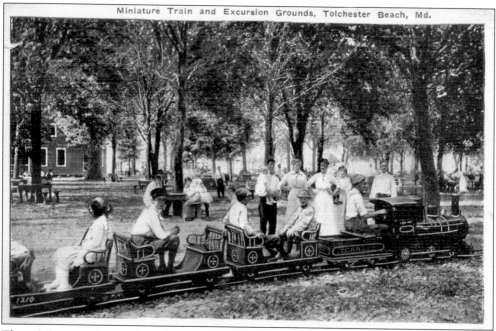

Miniature Train and Excursion Grounds, Tolchester Beach, Md.

The miniature train gave its riders a tour of the excursion grounds at Tolchester Beach. This postcard was published by Chessler and Oberender in Baltimore, Maryland.

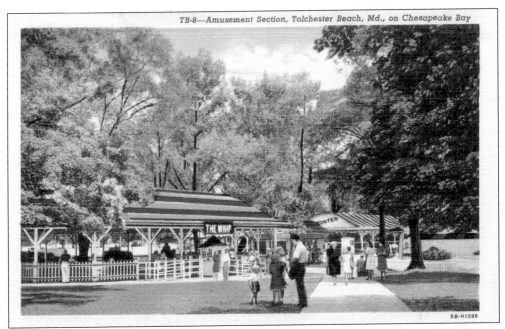

This card shows the entrance to two amusement rides at Tolchester. The whip and the skooter cars were popular rides for all ages. Other amusement rides at Tolchester included a merry-go-round with hand-carved animals, a roller coaster called the Whirl Pool Dips, boat rides, a fun house, bumper cars, a miniature train, pony rides, and swings. There were also food concession stands and arcades.

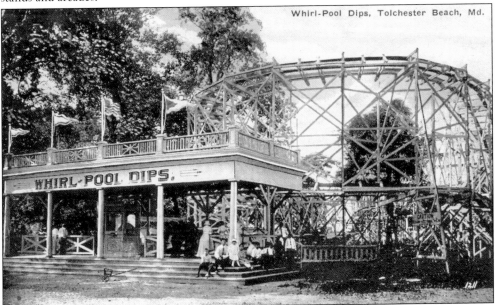

Whirl Pool Dips at Tolchester Beach was an exciting ride for visitors to the amusement park. The roller coaster came to America from Europe via Paris in the late 1870s. The initial ride lacked thrills, and dips were added that enhanced the excitement of the ride. This postcard was published by the Chessler Company, Baltimore, Maryland, and postmarked Tolchester Beach, Maryland, August 25, 1921.

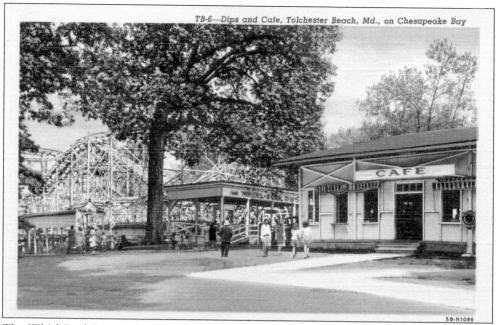

The Whirl Pool Dips and Café are pictured at Tolchester Beach. This card, No. TB-6, was published by the Harry P. Cann and Brothers Company, Baltimore, Maryland, in "genuine Curteich—C. T. Art-Colortone."

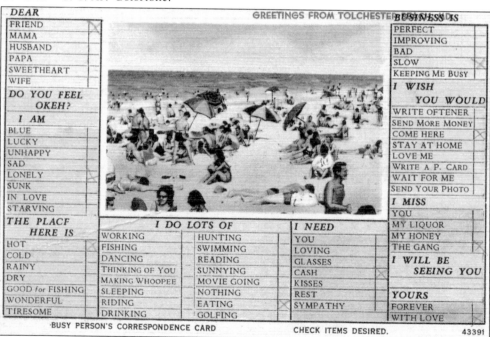

GREETINGS FROM TOLCHESTER

DEAR			BUSINESS IS
FRIEND			PERFECT
MAMA			IMPROVING
HUSBAND			BAD
PAPA			SLOW
SWEETHEART			KEEPING ME BUSY
WIFE			I WISH YOU WOULD
DO YOU FEEL OKEH?			WRITE OFTENER
I AM			SEND MORE MONEY
BLUE			COME HERE
LUCKY			STAY AT HOME
UNHAPPY			LOVE ME
SAD			WRITE A P. CARD
LONELY			WAIT FOR ME
SUNK			SEND YOUR PHOTO
IN LOVE			I MISS
STARVING			YOU
THE PLACE HERE IS	I DO LOTS OF	I NEED	MY LIQUOR
			MY HONEY
HOT	WORKING / HUNTING	YOU	THE GANG
COLD	FISHING / SWIMMING	LOVING	I WILL BE SEEING YOU
RAINY	DANCING / READING	GLASSES	
DRY	THINKING OF YOU / SUNNYING	CASH	
GOOD for FISHING	MAKING WHOOPEE / MOVIE GOING	KISSES	
WONDERFUL	SLEEPING / NOTHING	REST	YOURS
TIRESOME	RIDING / EATING	SYMPATHY	FOREVER
	DRINKING / GOLFING		WITH LOVE

BUSY PERSON'S CORRESPONDENCE CARD CHECK ITEMS DESIRED. 43391

This "Greetings from Tolchester Beach, MD" postcard was called a "Busy Person's Correspondence Card" where one would simply check items desired. Postcard No. 43391, series 1010–6–DES, was postmarked Chestertown, Maryland, on August 14, 1948. This card said, "Dear Friend, I am lonely. The place here is hot. I do lots of eating. I need cash. Business is slow. I wish you would come here. I miss the gang. Yours with love."

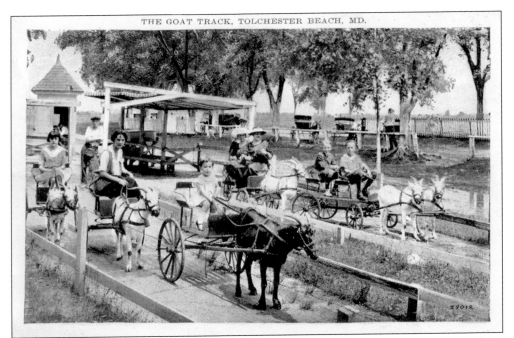

The goat track at Tolchester drew attention as goats pulled the carts through a portion of the park. This postcard was published by Harry P. Cann and Brothers in Baltimore, Maryland.

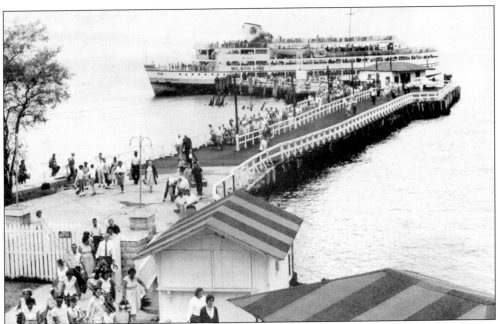

This postcard, dated in writing July 6, 1960, features the Wilson Line, which had operated on the Chesapeake Bay through the 1930s. In 1956, the Wilson Line and Tolchester Lines, Inc., worked out an agreement for the sister ships *Bay Belle* and *Tolchester*. The *Bay Belle* would run to Tolchester Park and to Betterton, Maryland, on the Chesapeake Bay, and the *Tolchester* would be used for charter trips.

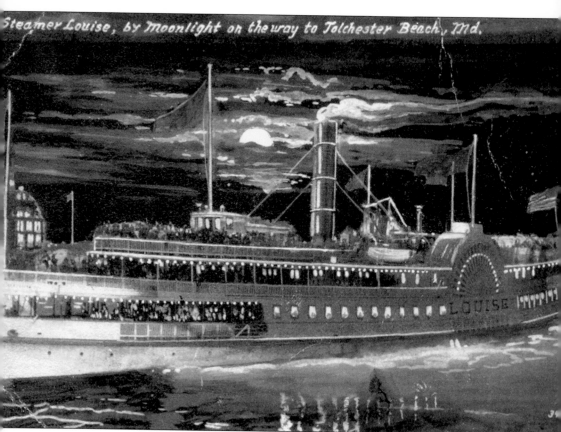

The steamer *Louise* travels by moonlight to Tolchester Beach, Maryland. This card was published by Chessler and Oberender, Baltimore, Maryland.

Four

BETTERTON

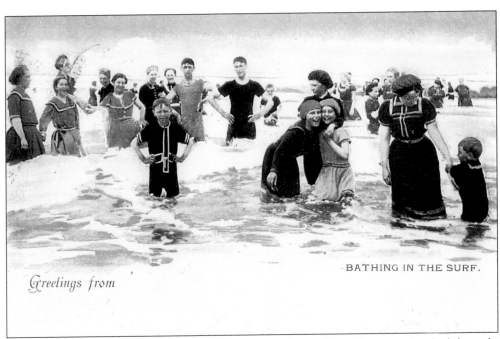

Greetings from

BATHING IN THE SURF.

The style of the bathing suits on both the women and men date this postcard, which brought greetings from Betterton Beach. The Bath House at Betterton was advertised as "well kept" with "good, clean suits." In 1925, the bathing suits were wool and one piece; the ladies added shoes and caps.

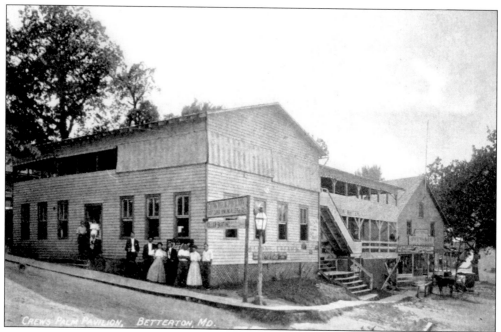

This postcard shows Crew's Palm Pavilion in Betterton. Four important families have been associated with Betterton's history beginning with the Crews and including the Owens, Brices, and Turners. The Crews were in Betterton from the beginning. Court records refer to an Edward Crew who settled on the farm where Betterton is now located way back in the early 1700s.

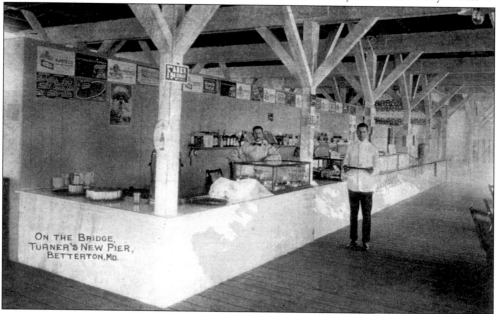

Turner's New Pier was located on the bridge in Betterton. It is said that Betterton, originally called Crew's Landing (for Edward Crew, a planter who lived in this area in the early 1700s), became a community in the 1850s when Richard Townsend Turner, a Baltimorean, moved from the "city" to the "country" on a 180-acre site set back from the shores of the Chesapeake Bay at the mouth of the Sassafras River.

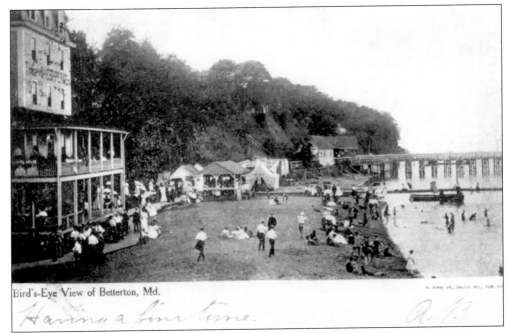

Bird's-Eye View of Betterton, Md.

Having a fine time. A. B.

The Chesapeake Hotel (House) was located right on the Chesapeake Bay beach at Betterton and was the center of much activity. Visitors enjoyed both bathing at the beach and walking along the beachfront.

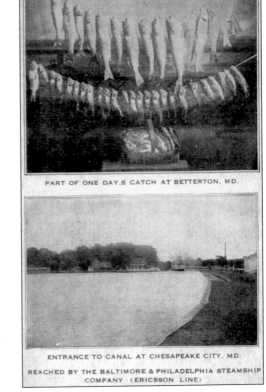

PART OF ONE DAY.S CATCH AT BETTERTON, MD.

ENTRANCE TO CANAL AT CHESAPEAKE CITY, MD.

REACHED BY THE BALTIMORE & PHILADELPHIA STEAMSHIP COMPANY (ERICSSON LINE)

This postcard entices fishermen to come to Betterton to fish. It shows the entrance to the canal at Chesapeake City and says that Betterton can be "reached by the Baltimore and Philadelphia Steamship Company (Ericsson Line)." Betterton was a fishing village in its earliest days.

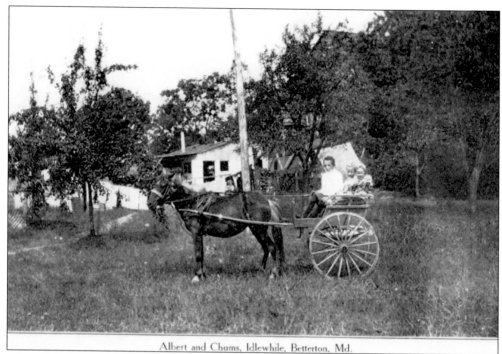

Albert and Chums, Idlewhile, Betterton, Md.

This postcard shows Albert and Chums in a pony cart near the Idlewhile guest house in Betterton.

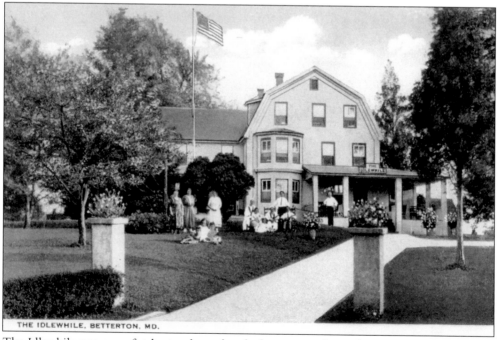

THE IDLEWHILE, BETTERTON, MD.

The Idlewhile was one of at least a dozen hotels that once welcomed vacationers to Betterton. Betterton's history reflects its association with the passenger steamboat on the Chesapeake Bay.

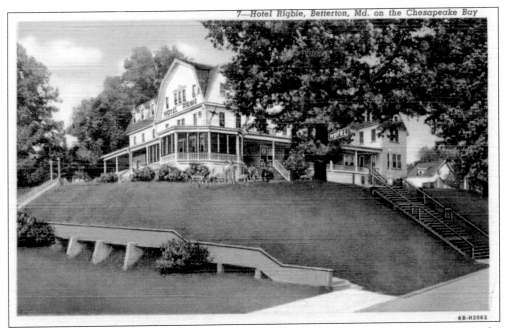

The Hotel Rigbie in Betterton, Maryland, on the Chesapeake Bay was demolished to make way for the Rigbie Condominiums that exist today. Today Betterton has a public beach with nettle-free swimming during the summer, bath houses, a fishing jetty, and picnic areas. This postcard, #7 (6B-H6062), was published by the Harry P. Cann and Brothers Company, Baltimore, Maryland, in genuine Curteich-Chicago "C. T. Art-Colortone."

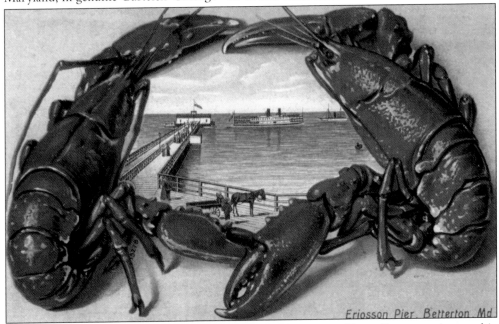

Eriosson Pier, Betterton, Md

This postcard used lobster claws to focus attention on the Ericsson Pier at Betterton. A steamship can be seen at the end of the pier. This bayside resort developed in response to people seeking leisure-time recreation. It was a popular destination for those from Baltimore and Philadelphia who enjoyed the excursions.

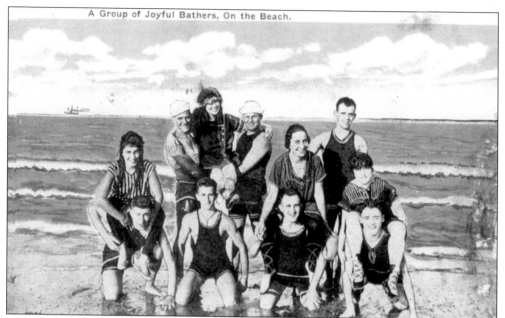

Bathing in the Chesapeake Bay was a favorite pastime of the many vacationers to Betterton. The Chesapeake Bay covers 2,500 square miles. It is an estuary, which is a partially enclosed area where the fresh water from rivers mixes with tidal salt water. The history of the Chesapeake Bay recounts that it was formed over 10,000 years ago when melting glacial ice caused sea levels to rise in the Atlantic Ocean. The rising waters of the Atlantic Ocean backed up into the Susquehanna River Valley, creating a new bay, now called the Chesapeake Bay.

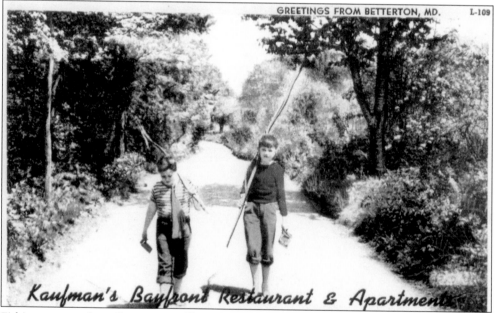

GREETINGS FROM BETTERTON, MD. L-109

Kaufman's Bayfront Restaurant & Apartments

Fishing was popular at Betterton, as illustrated by the two boys in this postcard who appear to be headed to their fishing spot with their poles. The card advertises Kaufman's Bayfront Restaurant and Apartments. Along with the several hotels available to vacationers were also apartments, cottages, and rooming houses.

The steamer *Susquehanna* was a popular sight at Betterton and Havre de Grace, Maryland. This steamer was built in 1898 for the Tolchester Beach Improvement Company by Charles Reeder and Sons, Baltimore.

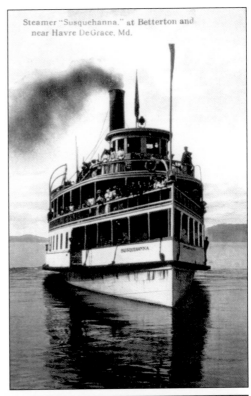

Steamer "Susquehanna," at Betterton and near Havre DeGrace, Md.

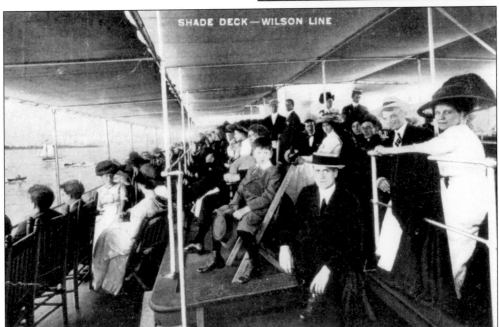

SHADE DECK—WILSON LINE

Ladies and gentlemen are pictured on what was called the "shade deck" on one of the ships of the Wilson Line. The Wilson Line operated on the Chesapeake through the 1930s. In 1942, they offered excursions on the *Bay Belle*, which boasted a modern amusement gallery and a dance hall. Operations came to a halt during wartime restrictions, but in 1946, excursions resumed to Betterton.

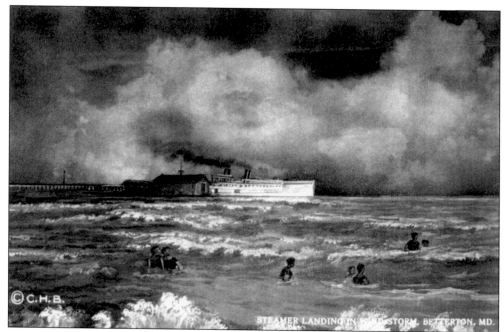

This postcard shows swimmers in the Chesapeake Bay against a background of a steamship docked at the Betterton pier and clouds swirling into a storm. In 1607, the Jamestown settlement was established on the James River. In 1608, sailing from Jamestown, Capt. John Smith was the first European to thoroughly explore and map the Chesapeake Bay.

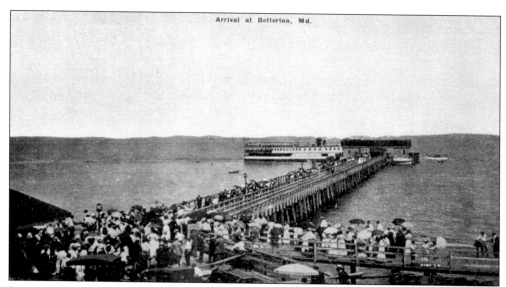

Passengers arrive at Betterton Beach from the ship docked at the end of the pier on the Chesapeake Bay. Chesapeake Bay waters have been traveled by all manner of ships throughout the ages, often specifically designed or modified to sail the Chesapeake's shallow waters.

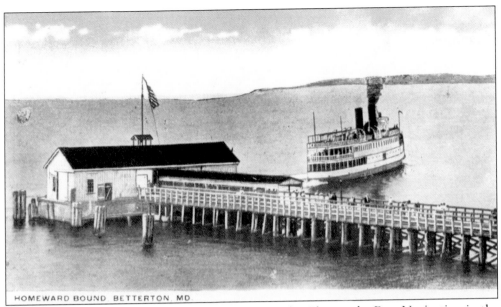

HOMEWARD BOUND BETTERTON, MD.

A steamship leaves the pier at Betterton Beach on the Chesapeake Bay. Navigation in the shallow waters of the Chesapeake Bay has been aided by a series of lighthouses. The first lighthouse built by the United States was built in 1792 at Cape Henry, marking the entrance to the Chesapeake Bay.

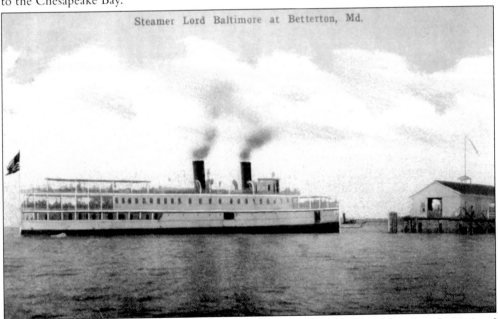

Steamer Lord Baltimore at Betterton, Md.

The steamer *Lord Baltimore* approaches the pier at Betterton. Betterton was placed on the National Register of Historic Places on June 7, 1984, by the U.S. Department of the Interior. The town is recognized as having a collection of vernacular Victorian resort structures still remaining within its incorporated boundaries. It is also recognized for overlooking the confluence of the Sassafras, Elk, Bohemia, and Susquehanna Rivers with the Chesapeake Bay. The area includes many of the homes, hotels, and cottages built to accommodate steamboat passengers in the late 19th and early 20th centuries.

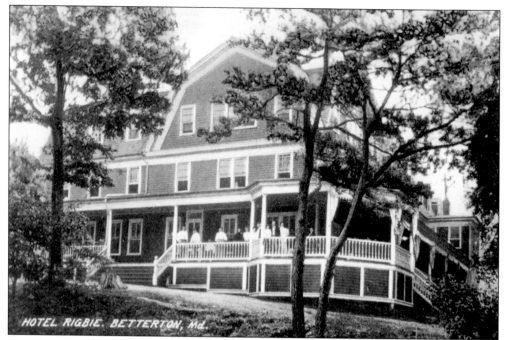

The Hotel Rigbie was one of the grandest hotels at Betterton Beach. It was located on a bluff overlooking the Chesapeake Bay and was owned once subsequently by the Turners, Brices, and Crews.

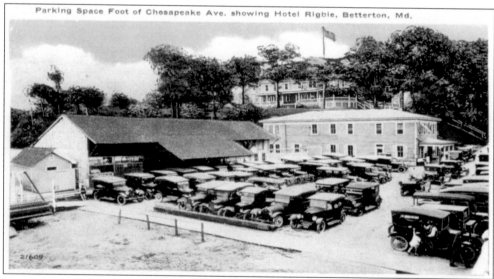

The cars are shown in the parking space at the foot of Chesapeake Avenue in Betterton. The Hotel Rigbie can be seen on the hill. In 1930, Betterton advertised "bathing" and "fishing" and that it was the "Chesapeake Bay's most beautiful beach." It was known as a summer resort with a year-round industry of fishing. Betterton is located at the mouth of the Sassafras River where five rivers empty into the Chesapeake Bay. This card was published by Owens and Company of Betterton, Maryland.

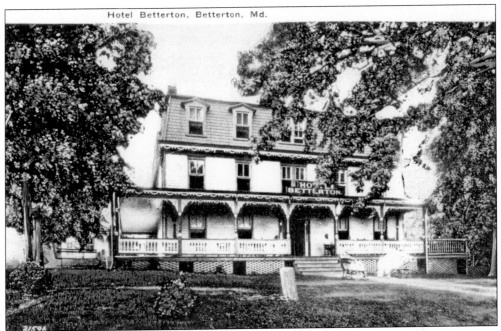

The Hotel Betterton was among a number of hotels that welcomed visitors to Betterton Beach on the Chesapeake Bay. It was famous for its Eastern Shore dinners of seafood and fresh vegetables.

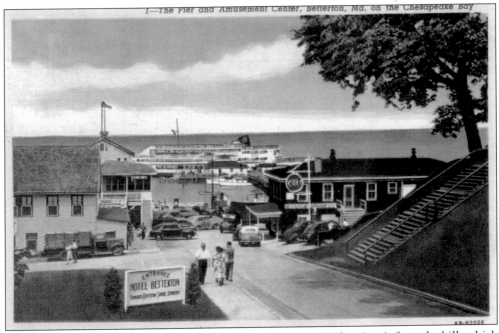

I—The Pier and Amusement Center, Betterton, Md. on the Chesapeake Bay

The entrance to the Hotel Betterton is shown in this postcard. The view is from the hill, which ends on the Chesapeake Bay beach. Betterton Hardware Company with its Gulf gas sign can be seen on the right. The pier and amusement center are also shown.

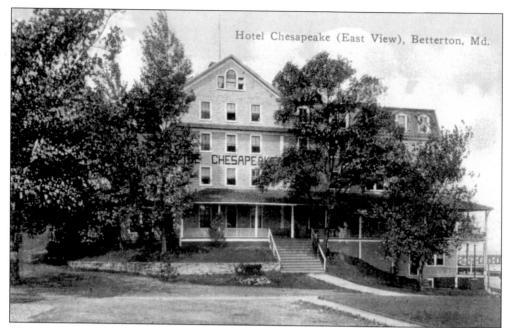

The Hotel Chesapeake was located in Betterton on Ericsson Avenue. This card, No. 13807, was published by Owens and Company of Betterton; printed by Baltimore Stationery Company in Baltimore, Maryland; and postmarked from Betterton on July 27, 1911.

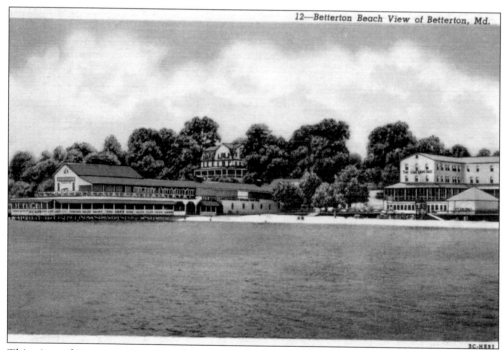

This view of Betterton from the Chesapeake Bay is what greeted the many vacationers arriving by ship. The Hotel Rigbie sits atop the hill in the center, and the Chesapeake Hotel can be seen to the right.

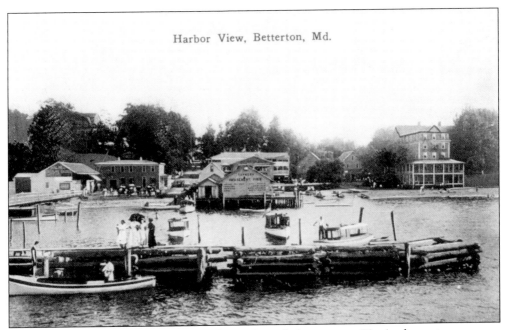

Harbor View, Betterton, Md.

This view of Betterton from the water shows Turner's Amusement Pier in the center.

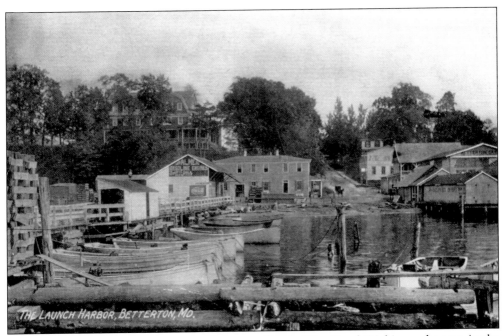

THE LAUNCH HARBOR, BETTERTON, MD.

Launches were available at the pier at Betterton Beach. The Hotel Rigbie can be seen in the background through the trees.

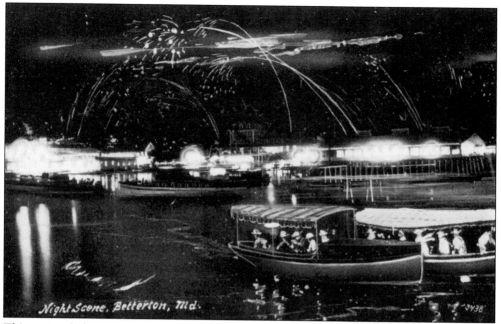

This postcard photo might have been taken during a Fourth of July celebration at Betterton.

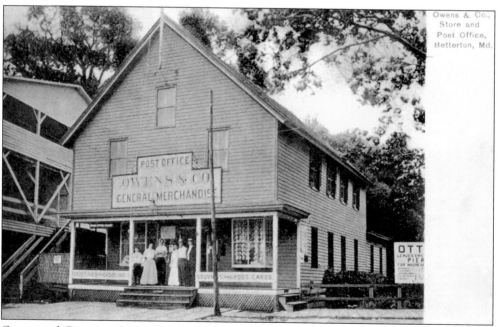

Owens and Company General Merchandise was also the home of the Betterton Post Office.

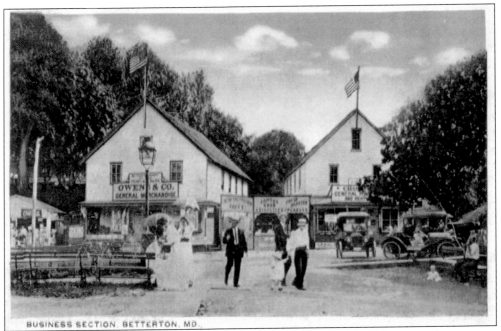

The "business section" of Betterton Beach, shown here, included Owens and Company General Merchandise.

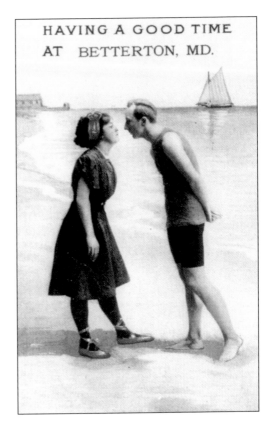

Two vacationers enjoy Betterton Beach amidst the backdrop of a log canoe.

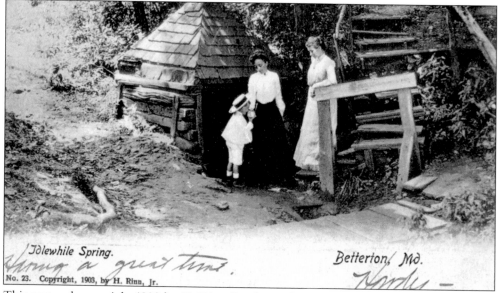

This postcard, copyright 1903 by H. Rinn Jr., shows the women and a child at the Idlewhile Spring. An old fishing ark, built by Scott Crownhart in 1890, which has been sitting at the end of Idlewhile Avenue for a long time, is set to be restored. Crownhart owned and ran hotels in Betterton and was listed as a "hotel keeper" on the 1900 census. Shanties were towed behind a fishing boat and pulled onto the marsh to house the men during the one- to two-week fishing trips to the Chesapeake Bay.

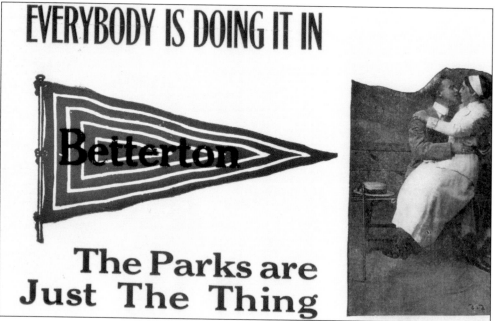

This postcard advertises that "everybody is doing it in Betterton." Betterton offered spectacular views to visitors along with fishing and swimming. The town created several parks for the enjoyment of visitors. These parks included the beach area, a footbridge that connected Bayside Boulevard and Boulevard Street, and a small area with beaches facing the Sassafras River along Bayside Boulevard.

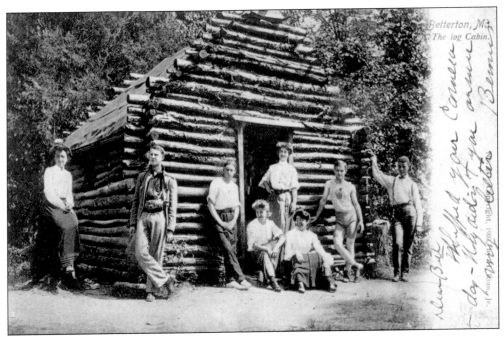

This log cabin was located in Betterton.

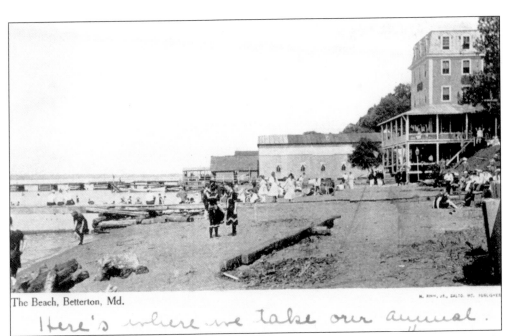

The Beach, Betterton, Md.

Betterton Beach was a popular summer vacation spot and at one time was home to several hotels, dance pavilions, and beach entertainment. When Richard Townsend Turner moved his family to Betterton from Baltimore in 1850, he named the area Betterton after his wife, Elizabeth Betterton Turner. The name Betterton came from an old Philadelphia family.

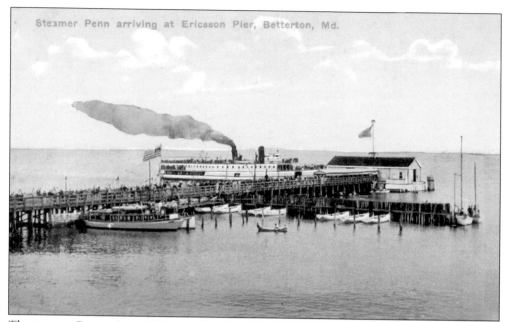

The steamer *Penn* arrives at Ericsson Pier in Betterton. This card, No. 41, was published by the Chessler Company in Baltimore, Maryland.

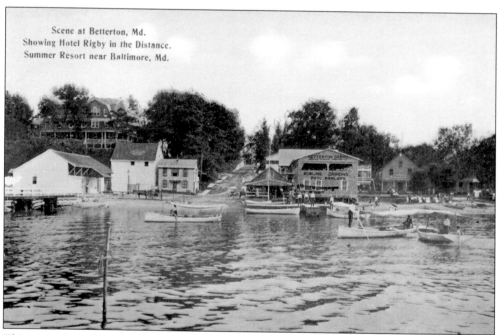

This scene at Betterton shows the Hotel Rigbie in the distance. Noted as a summer resort near Baltimore, Betterton is located at the mouth of the Sassafras River. At one time, the town supported 13 hotels and many boarding houses during the summer months.

The steamer *Susquehanna* is discharging passengers at a Betterton summer resort. This card was published by the Chessler Company of Baltimore and postmarked Baltimore on July 6, 1915.

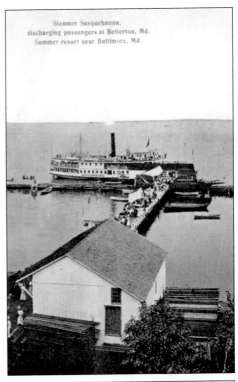

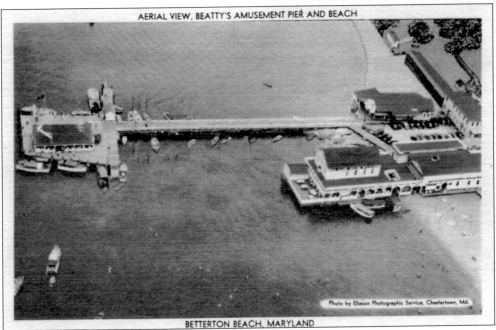

This aerial view is of Beatty's Amusement Pier at Betterton Beach. The photo was taken by Eliason Photographic Service, Chestertown, Maryland. "Daily excursions on the Bay Belle leaves from the Wilson Line Pier in Baltimore for a delightful three hour cruise up the Chesapeake Bay to Betterton or can also be reached by automobile." This card, #12-709F, was published by Hugh M. Miller Jr., Rock Hall, Maryland.

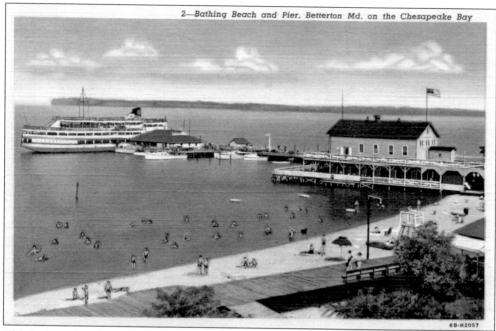

2—Bathing Beach and Pier, Betterton Md. on the Chesapeake Bay

6B-H2057

This bathing beach and pier are located on the Chesapeake Bay at Betterton. Postcard No. 2 (6B-H2057) is postmarked August 1, 1950, from Betterton. It was published by the Harry P. Cann and Brothers Company, Baltimore.

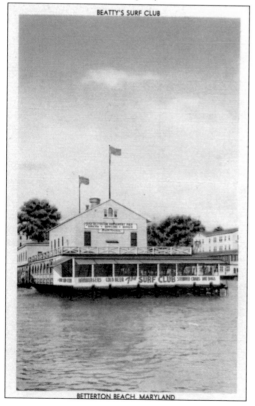

BEATTY'S SURF CLUB

BETTERTON BEACH, MARYLAND

Beatty's Surf Club on Betterton Beach is the destination for many visitors. This card, #12-708F, was published by Hugh M. Miller Jr., Rock Hall, Maryland.

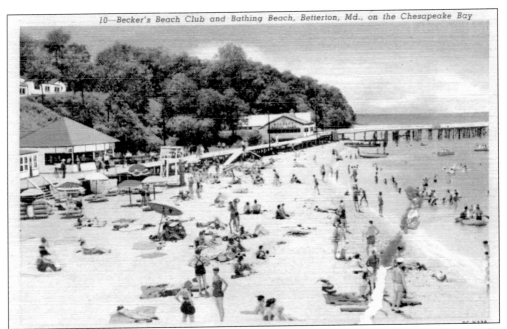

10—Becker's Beach Club and Bathing Beach, Betterton, Md., on the Chesapeake Bay

Becker's Beach Club and Bathing Beach in Betterton, Maryland, is located on the Chesapeake Bay. This card, No. OC-H338, was postmarked in Betterton July 10, 1954. It was published by the Harry P. Cann and Brothers Company, Baltimore, in "Genuine Curteich-Chicago C. T. Art-Colortone."

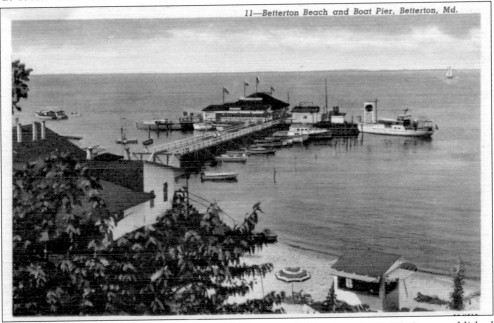

11—Betterton Beach and Boat Pier, Betterton, Md.

Betterton Beach and Boat Pier are shown in this postcard, No. 11 (3C-H590). It was published by the Harry P. Cann and Brothers Company. Betterton Beach was first known as Fish Hall and then called Crew's Landing when it was a fishing center. It took on a new name and new industry with the coming of the steamboat. The Turner family was instrumental in the development of the town, which was named for Richard Turner's wife, Elizabeth Betterton.

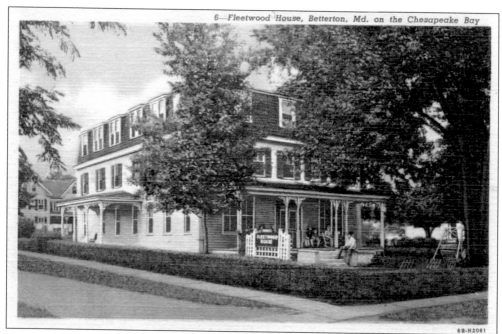

Fleetwood House was located on the Chesapeake Bay in Betterton. Postcard No. 6B–H2061 was published by the Harry P. Cann and Brothers Company in Baltimore in "Genuine Curteich-Chicago C. T. Art-Colortone."

This is the back of a postcard dated June 23, 1953, and postmarked from Betterton. The sender of the card had arrived on the *Bay Belle*.

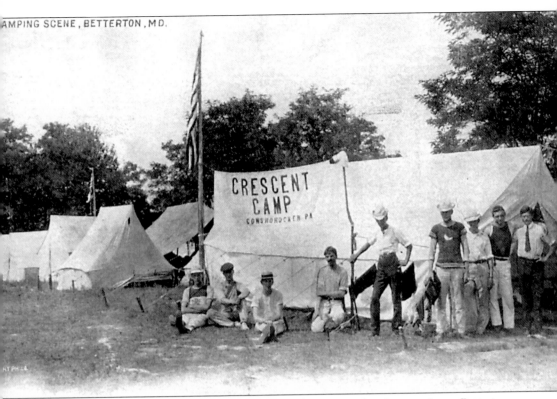

This postcard shows the Crescent Camp of Conshohocken, Pennsylvania, camping at Betterton.

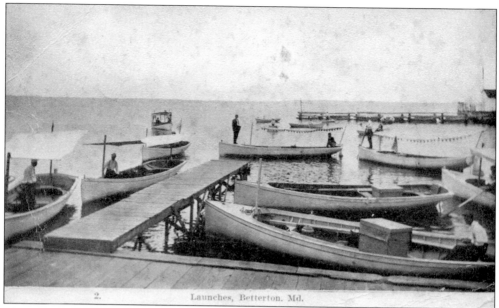

These launches in Betterton were made available to vacationers. This card was published by Owens and Company in Betterton and postmarked Kennedyville, Maryland, in 1911. The message was dated January 1, 1911. Among the hotels offering lodging to guests were the Chesapeake Hotel, Idlewhile Hotel, Jewell Cottage, Atlantic Hotel, Southern Hotel, Emerson Hotel, Belmont Hotel, Price Cottage, Rose Lawn Cottage, Maplewood Hotel, Owens Cottage, Ferncliff Hotel, Shadylawn Cottage, Betterton Hotel, Royal Swan Hotel, Rigbie Hotel, and Maryland Hotel.

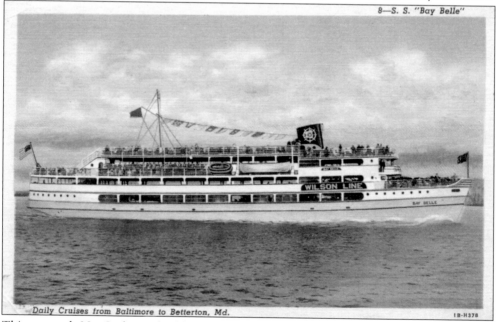

This postcard, No. 8, shows the SS *Bay Belle*, which offered daily cruises from Baltimore to Betterton. As many as 2,500 people would arrive on the *Bay Belle* during the 1940s. The card was published by the Harry P. Cann and Brothers Company of Baltimore in genuine Curteich-Chicago "C. T. Art-Colortone."

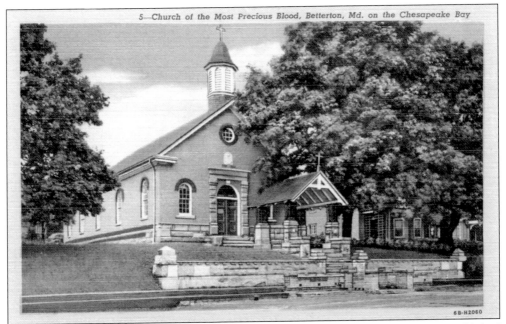

6B-H2060

Postcard No. 5, the Church of the Most Precious Blood in Betterton (6B-H2060), was published by the Harry P. Cann and Brothers Company in Baltimore, Maryland, in genuine Curteich-Chicago "C. T. Art Colortone."

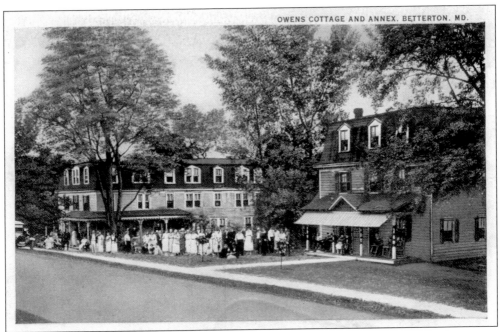

OWENS COTTAGE AND ANNEX. BETTERTON. MD.

Betterton once had at least 20 hotels and boarding or rooming houses, including Owens Cottage and Annex. There were enough rooms for 3,500 visitors. This card was published by Louis Kaufmann and Sons, Baltimore, Maryland. It was made in the United States.

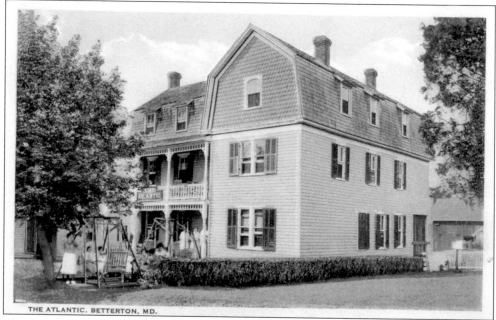

THE ATLANTIC. BETTERTON, MD.

The Atlantic Hotel in Betterton was one of the many hotels that provided accommodations to visitors. This card was published by Louis Kaufmann and Sons in Baltimore and was made in the United States using "C. T. American Art."

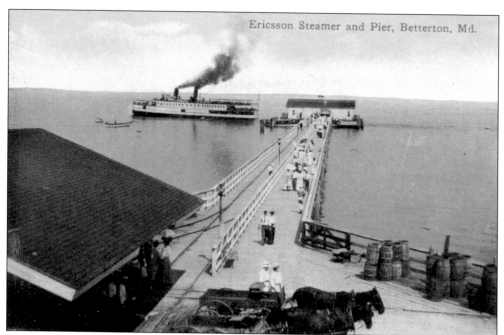

Ericsson Steamer and Pier, Betterton, Md.

The *Ericsson* steamer can be seen at the pier in Betterton. In 1930, the Ericsson Line had a new boat, *The John Cadwalader*, which ran between Baltimore and Philadelphia, landing at Betterton. The Tolchester Company ran boats to Betterton from Baltimore and Pennsylvania Railroad to Still Pond. This postcard, No. 5945, was published by Owens and Company in Betterton and printed by Baltimore Stationery Company in Baltimore.

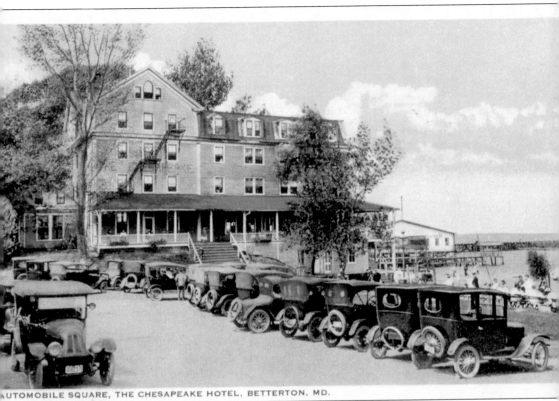

AUTOMOBILE SQUARE, THE CHESAPEAKE HOTEL, BETTERTON, MD.

Automobile Square was located at the Chesapeake Hotel, Ericsson Avenue, on the Chesapeake Bay at Betterton. This postcard was published by Louis Kaufmann and Sons, Baltimore, Maryland, and it was made in the United States using "C. T. American Art." It cost 1¢ to mail domestic and 2¢ to mail foreign.

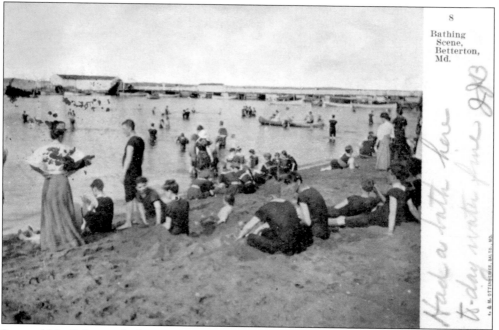

Postcard No. 8 shows a bathing scene at Betterton. The pier in the background was used for the loading and unloading of cargo, such as peach baskets or farm machinery or animals. This card was published by I and M Ottenheimer, Baltimore, Maryland, and was postmarked in Betterton on August 8, 1907.

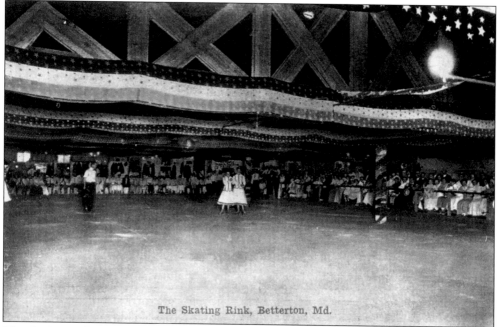

The skating rink was one of the many amusements available to visitors at Betterton. At one time, there was a "casino," which was really a double-decker amusement pier that was partly over water. There was also a dancing hall above a bowling alley. The dance hall was also used for motion pictures.

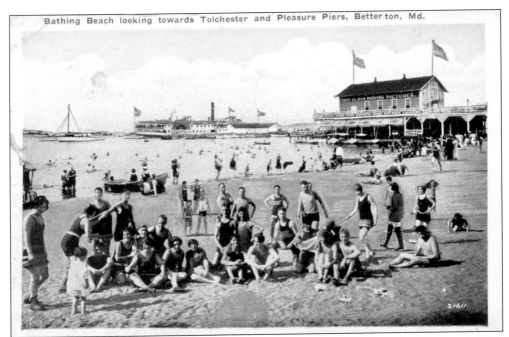

Tolchester and Pleasure Piers can be seen in the background of Betterton's bathing beach. This postcard, No. 21611, was published by Owens and Company, Betterton. It was made in the United States and postmarked Betterton on July 24, 1928.

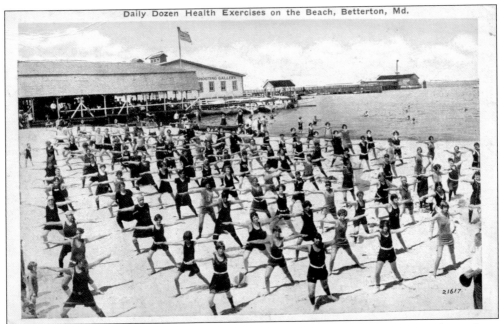

This card depicts the "Daily Dozen Health Exercises on the Beach" at Betterton. The card was published by Owens and Company, Betterton, and made in the United States. It was postmarked Betterton, Maryland, July 24, 1928.

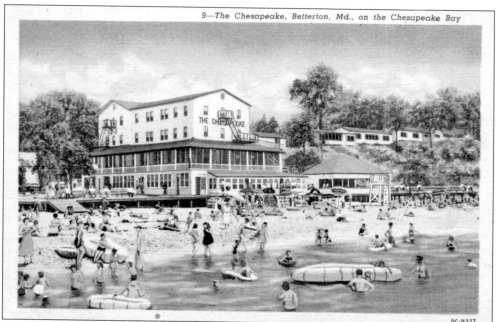

OC-H337

The Hotel Chesapeake in Betterton is located on the Chesapeake Bay. This postcard, No. 9 (OC-H337), was published by the Harry P. Cann and Brothers Company in Baltimore, Maryland, in genuine Curteich-Chicago "C. T. Art-Colortone." The Hotel Chesapeake and cottages were located on the beach, offering a European plan, bathing, swimming, fishing, cruising, and amusements, with a modern dining room serving good Eastern Shore food at minimum prices.

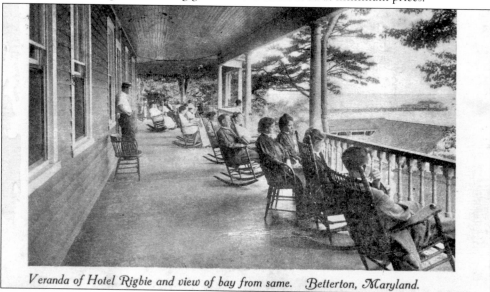

Veranda of Hotel Rigbie and view of bay from same. Betterton, Maryland.

This card shows the veranda of the Hotel Rigbie and view of the Chesapeake Bay in Betterton. Known as "Betterton's finest hotel," its capacity was 150. The Rigbie offered banquets, dinner parties, and luncheons with special menus served by reservation. Amusements at the beach included bumper cars, the whip, crazy house, and an arcade. The hotel was open from May to October. The most expensive room was on the second floor with a private bath for $60 per week, which included two meals a day. The card was published by C. B. Whitby in Baltimore, Maryland.

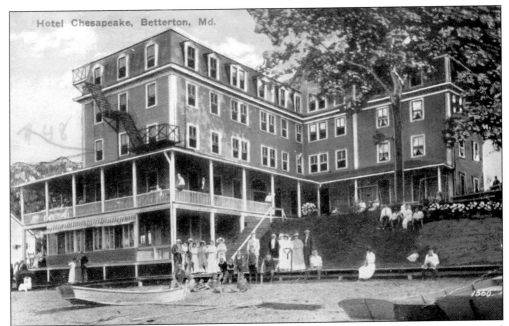

The Hotel Chesapeake in Betterton advertised itself in 1930 as the most attractive resort hotel in Betterton. "Modern in every respect, closest to the Beach—make your reservations early." Jack Owens was the owner and manager at this time. This card was published by the Chessler Company from Baltimore, Maryland.

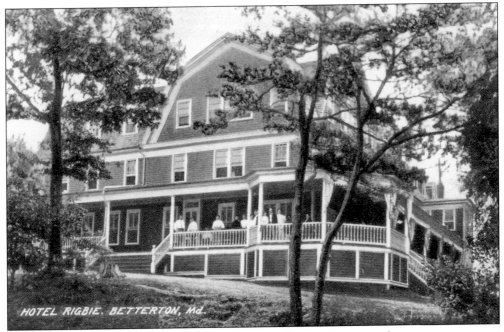

In 1930, the Hotel Rigbie in Betterton was advertising running water in every room, resort accommodations of the highest quality, and meals that are masterpieces. This postcard published by Owens and Company in Betterton was made in Germany and was printed by Baltimore Stationery Company in Baltimore.

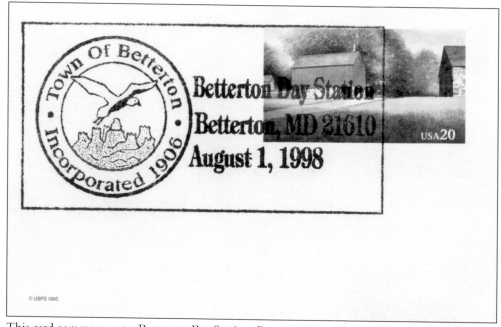

This card commemorates Betterton Bay Station, Betterton, Maryland 21610 on August 1, 1998, It shows the town of Betterton was incorporated in 1906.

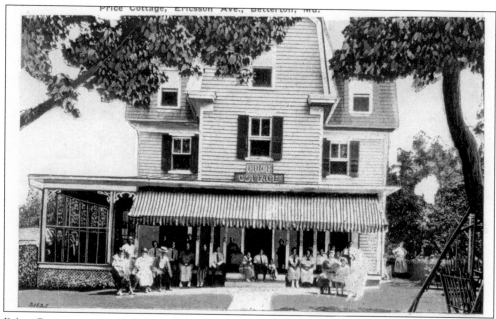

Price Cottage was one of the many accommodations available to visitors at Betterton Beach in the 1900s. Stoneton, a farm along the Sassafras River from the town limits of Betterton to Turner's Creek, was a beautiful and historic farm owned by the Price family. Stoneton belonged to the Prices for five generations until it passed from the family in 1973. The owners included John Hyland Price, William Henry Price, Charles Henry Price, and Nancy Maxwell Price.

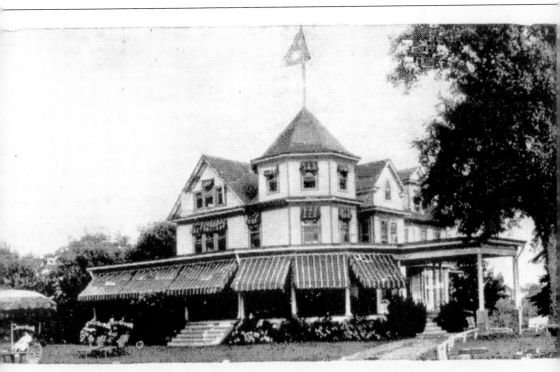

ROYAL SWAN HOTEL, BETTERTON, MD.

The Royal Swan Hotel was one of the hotels available to Betterton visitors. At one point in Betterton's history, there were two main piers, the Tolchester and the Ericsson. The piers were also used at various times to load and unload goods and produce, including peach baskets and machinery. Barrels of Betterton spring water were sent over to the Baltimore saloons.

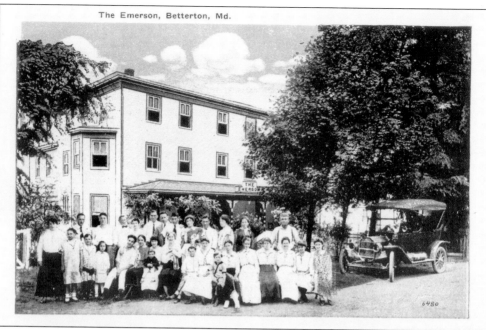

The Emerson, Betterton, Md.

The Emerson Hotel in Betterton was another of the many hotels that provided rooms to vacationers. An "amusement pier" is said to have been constructed about 1887 for the pleasure of the many summer visitors. It was said that the winter population of Betterton in the early 1900s was about 300 people. This number swelled to as many as 3,500 people in the summer.

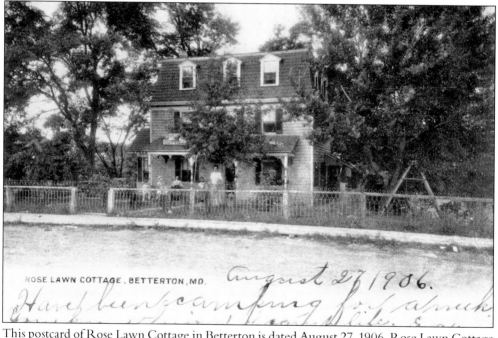

ROSE LAWN COTTAGE, BETTERTON, MD.

This postcard of Rose Lawn Cottage in Betterton is dated August 27, 1906. Rose Lawn Cottage was built by George Owens. Owens, along with Benjamin Wheeler and Ebenezer Crew, was on the first board of trustees (1868) of the Betterton Methodist Church. The sender of the card writes about camping.

Five

OUTLYING AREAS

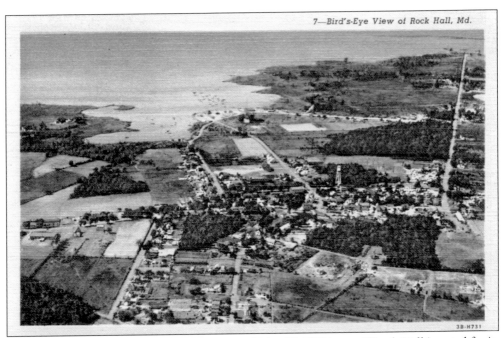

This is a bird's-eye view of Rock Hall. Postcard No. 3B–H731 says, "Rock Hall is noted for its 'Sea Food Industry' and many sportsmen enjoy angling on the Chesapeake Bay." The card was published by the Harry P. Cann and Brothers Company in Baltimore, Maryland, in "Genuine Curteich-Chicago C. T. Art-Colortone."

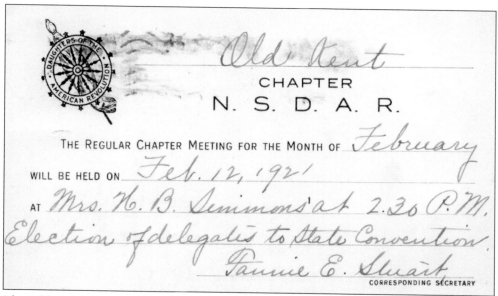

Old Kent

CHAPTER

N. S. D. A. R.

THE REGULAR CHAPTER MEETING FOR THE MONTH OF *February*

WILL BE HELD ON *Feb. 12, '921*

AT *Mrs. N. B. Simmons' at 2.30 P.M.*

Election of delegates to State Convention.

Fannie E. Stuart

CORRESPONDING SECRETARY

This Old Kent Chapter of the National Society of the Daughters of the American Revolution meeting notice is dated February 21, 1921, and signed by Fannie E. Stuart, corresponding secretary. The postcard was sent to a group of ladies about a DAR meeting.

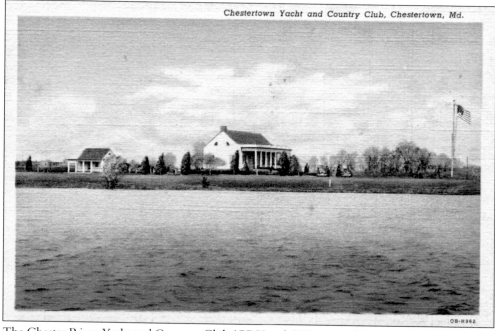

Chestertown Yacht and Country Club, Chestertown, Md.

The Chester River Yacht and Country Club (CRY and CC) was built in 1928 as an all-purpose family club, complete with swimming, boating, tennis, and golf. The tennis courts were removed in 1935. It has been reported that the old wooden Chester River Bridge had been dismantled, and its wood was floated down the river to create a 14-slip pier for the new club. The CRY and CC today has an 18-hole golf course along with the pier and boat slips.

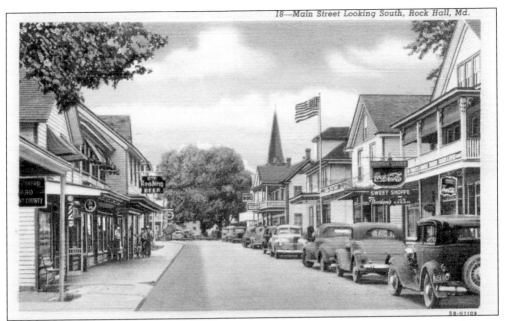

This card shows Main Street looking south in Rock Hall. As early as 1776, Rock Hall was a thriving community and the terminus of a ferry that connected it with Annapolis. Col. Tench Tilghman used the ferry when he carried the news of General Cornwallis's surrender to the Continental Congress at Philadelphia in 1781. Rock Hall was once a busy fishing, oystering, and canning community. Postcard No. 18 was published by the Harry P. Cann and Brothers Company in Baltimore in genuine Curteich-Chicago "C. T. Art-Colortone."

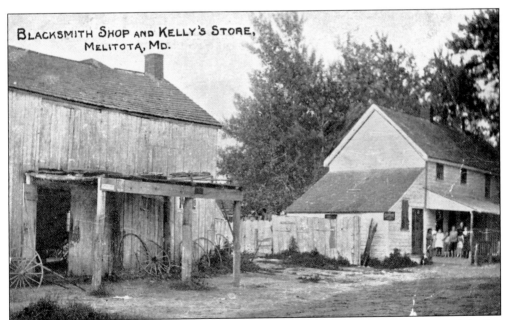

Melitota is located in the third district of Kent County, which is called the Worton District. This postcard shows the blacksmith shop and Kelly's Store located in Melitota. It was published by Louis Kaufmann and Sons, Baltimore, Maryland, series 154.

101

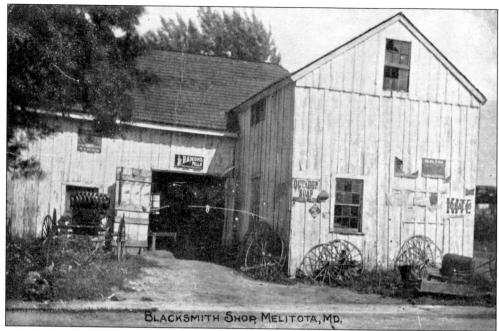

The blacksmith shop at Melitota is shown in this postcard, which was published by Louis Kaufmann and Sons, Baltimore, series 154.

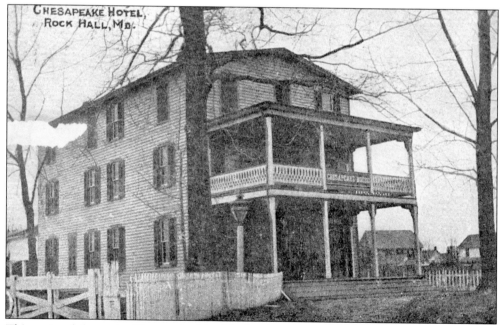

This postcard shows the Chesapeake Hotel in Rock Hall.

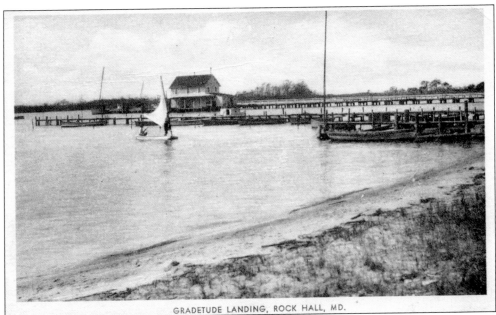

GRADETUDE LANDING, ROCK HALL, MD.

Gradetude Landing, now spelled "Gratitude," is located in Rock Hall. It is said that Gratitude was first known as Deep Landing and that the name "Gratitude" was borrowed from the name of the steamboat that regularly docked at the landing in the late 1800s. Today there is a Gratitude Yachting Center, which advertises itself as the oldest continuous yacht sales and charter organization on the Eastern Shore, and Gratitude Marina has 80 boat slips of all sizes right on the Chesapeake Bay. This postcard was published by Art Photo, Elizabeth, New Jersey.

The scenery in this "Greetings from Rock Hall, MD" postcard looks very generic. The card (S-516) was published by Curt Teich and Company, Inc.—#187, C. T. Group Scenics—10 subjects in genuine Curteich-Chicago "C. T. Art-Colortone." It was postmarked Rock Hall, Maryland.

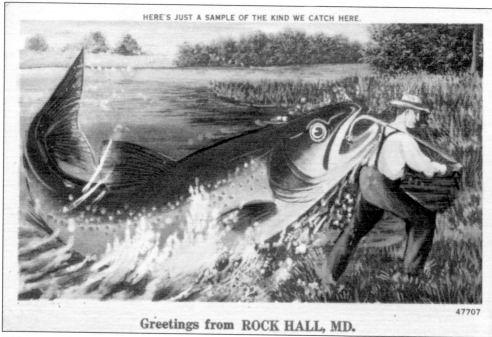

HERE'S JUST A SAMPLE OF THE KIND WE CATCH HERE.

47707

Greetings from ROCK HALL, MD.

This postcard says "Greetings from Rock Hall, MD.—Here's just a sample of the kind we catch here." Postcard, No. 925 (47707), Freak Fish Locals, was postmarked Rock Hall, Maryland, on September 13, 1952.

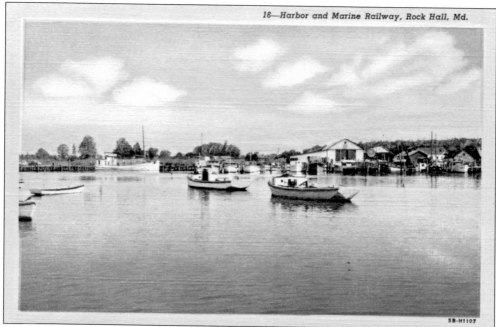

16—Harbor and Marine Railway, Rock Hall, Md.

5B-H1107

The Rock Hall Harbor, with Leary's Rock Hall Marine Railway in the background, is shown in this postcard. The Rock Hall Marine Railway was established in 1936 by Elmer Leary and operates today in the same location. Postcard No. 16 (5B-H1107) was published by the Harry P. Cann and Brothers Company, Baltimore, in genuine Curteich-Chicago "C. T. Art-Colortone."

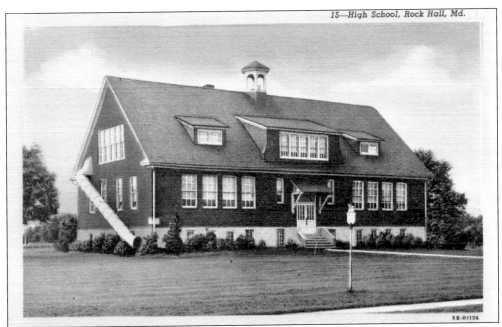

The Rock Hall High School was erected in 1915, and a wing was added in 1949 and 1950 and consisted of a gymnasium/auditorium, principal's office, typing room, cafeteria, lockers, and showers. This postcard, No. 15, was published by the Harry P. Cann and Brothers Company in Baltimore in genuine Curteich-Chicago "C. T. Art-Colortone."

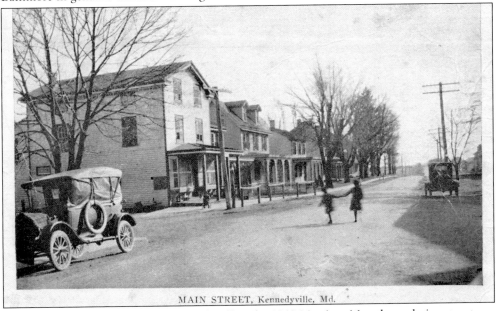

MAIN STREET, Kennedyville, Md.

This card shows Main Street in Kennedyville. The 1860 Martinet Map showed nine structures in Kennedyville, including a hotel and blacksmith shop. The 1877 Atlas shows the Kent Railroad with its depot at the northeast end of town. Also shown was the United Methodist Church, which remains today. The old post office was in the home of J. B. Weer, and public school No. 4 stood at the south edge of town. This card was published by A. M. Simon, 113 Mercer Street, New York City. It was postmarked Kennedyville, Maryland, on March 25, 1925.

The back of this postcard of Main Street, Kennedyville, is addressed to Miss Grace Noland in Chestertown and postmarked March 25, 1925, from Kennedyville. The Kennedyville Train Station building was moved to Greenbank Station near Wilmington, Delaware, in 1963. It was moved to Hockessin, Delaware, in 1993 where it remains.

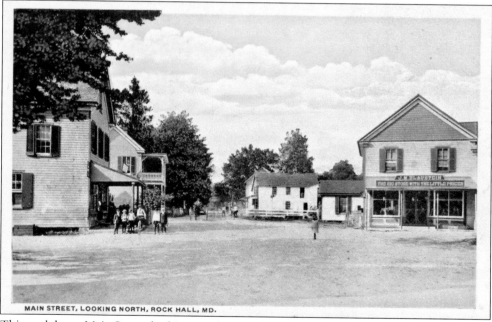

MAIN STREET, LOOKING NORTH, ROCK HALL, MD.

This card shows Main Street, looking north in Rock Hall. It is said that Rock Hall was founded in 1707. The community of Rock Hall started as a home for fishermen. This card, No. A-52165, was published by Louis Kaufmann and Sons, Baltimore, publisher of local views, and made in the United States. It was postmarked Rock Hall, Maryland, September 3, 1915.

This is the back of the previous Main Street postcard showing the postmark from Rock Hall on September 3, 1915. It was addressed to Miss Daisy Ford, Kennedyville, from Mr. N. Saterfield.

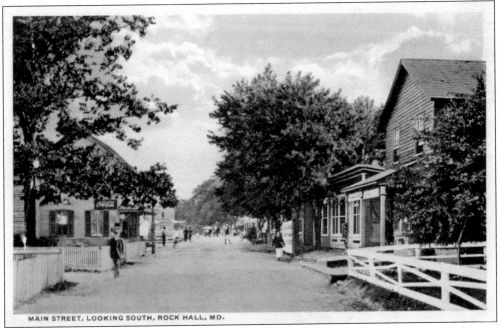

MAIN STREET, LOOKING SOUTH, ROCK HALL, MD.

This is the view from Main Street, looking south, in Rock Hall. Rock Hall was formerly known as Rock Hall Cross Roads. Its Main Street is part of the first road cut in Kent County in 1675. George Washington passed here eight known times. Col. Tench Tilghman used this route from Yorktown to Philadelphia in October 1781.

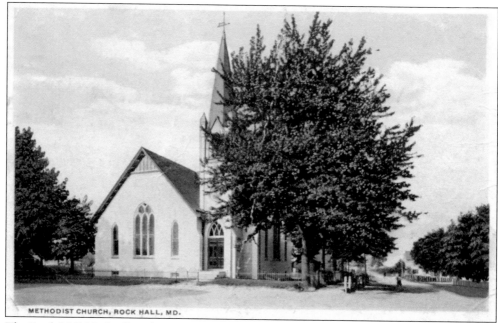

METHODIST CHURCH, ROCK HALL, MD.

The Rock Hall Methodist Church is shown on this postcard, which was postmarked Rock Hall, Maryland, on August 16, 1919. This building was erected in the latter part of 1900. This church had its beginnings in 1821 when property to erect a church building was bought by Charles Rigby, William Copper, William R. Durding, William Downey, Jacob Stevens, and John K. Ayres. These men became "trustees" to see that a chapel was erected and whatever ground was left was to be used for a cemetery. This card was published by Louis Kaufmann and Sons, Baltimore, "Publisher of Local Views," and made in the United States.

The New Hall, Rock Hall, Md.

This card shows "The New Hall" in Rock Hall. The Methodists were the earliest religious body to settle in Rock Hall and set up a place of worship. Rock Hall dates back to Colonial times when it was the eastern station of a ferryboat line from Annapolis. (Courtesy Talbot County Free Library, Maryland Room.)

The Vestry House of Old St. Paul's Church Parish near Rock Hall was founded in 1683. Old St. Paul's is the oldest Episcopal parish in Kent County. Built in 1766, the Vestry House cost at the time 20,000 pounds of tobacco. It is now used as the church Sunday school. This postcard was published by Durding's Drug Store, Rock Hall. Imprinted on the card is, "Postcards of Quality—The Albertype Company, Brooklyn, NY." It was postmarked at Chestertown, Maryland, July 6, 1939.

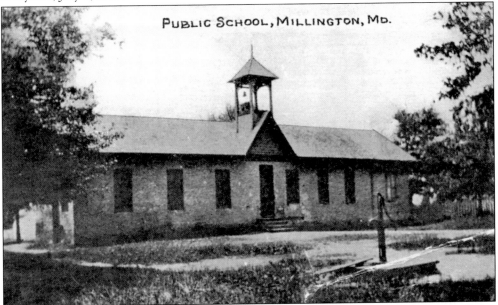

The public school in Millington was called the Millington Academy. It was built in 1813 to serve the educational needs of the community. It is reported to have begun as a two-story structure but became a one-story building after a fire in the late 1800s. The building is used as a residence today. This card, No. K −1159, was published by Louis Kaufmann and Sons, Baltimore, Maryland.

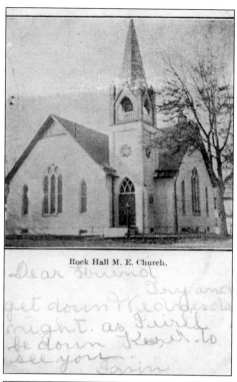

Rock Hall M. E. Church.

The Rock Hall M.E. Church is shown on this card postmarked Rock Hall, Maryland, April 30, 1907. It was marked "Rec" (received) Chestertown.

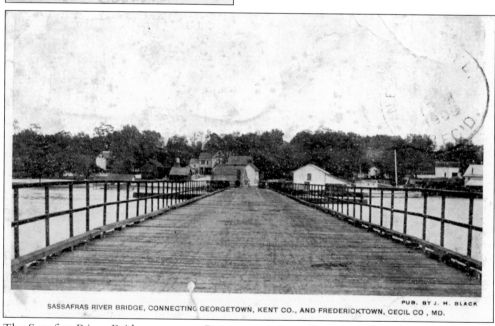

SASSAFRAS RIVER BRIDGE, CONNECTING GEORGETOWN, KENT CO., AND FREDERICKTOWN, CECIL CO., MD.
PUB. BY J. H. BLACK.

The Sassafras River Bridge connects Georgetown, Kent County, and Fredericktown, Cecil County. Georgetown was erected by an Act of Assembly of Maryland in May 1768. It was a base of continental supplies from 1775 to 1783 and a port of entry and ferry landing. George Washington stopped in Georgetown en route to points north and south. Georgetown was burned by the British on May 6, 1813. This card was published by J. H. Black. The front postmark says "Rec'd" Newark 1909. A second postmark was at Cecilton, Maryland, August 9, 1909.

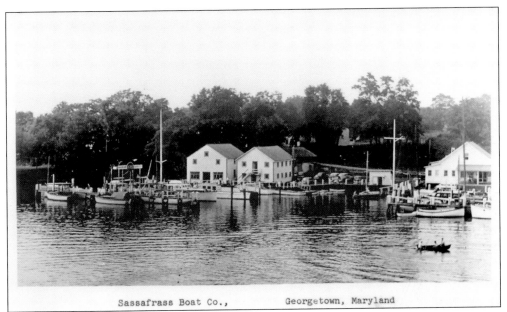

Sassafrass Boat Co., Georgetown, Maryland

The Sassafras Boat Company in Georgetown is seen from the Kent County side of the Sassafras River. It was owned and operated by John Wilson. The boatyard boasted a restaurant and a store. It is called Sassafras Harbor Marina today and offers amenities. Capt. John Smith entered Kent County in the early 15th century on the river named Tockwough, known today as the Sassafras. This card was published by Delmar Photo Service, Inc., Wilmington, Delaware. It was made in the United States.

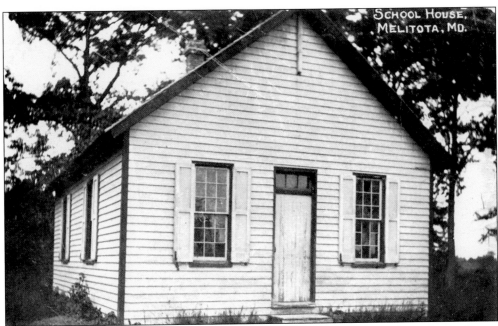

SCHOOL HOUSE, MELITOTA, MD.

The schoolhouse in Melitota is shown on this postcard, which was published by Louis Kaufmann and Sons in Baltimore, Maryland, series 154.

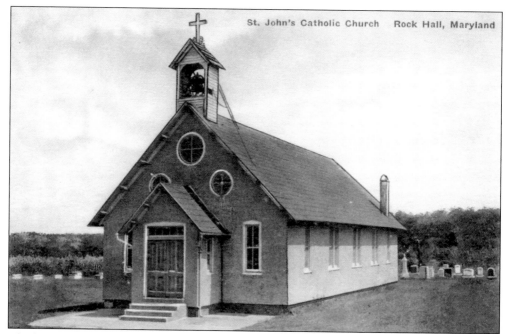

St. John's Catholic Church Rock Hall, Maryland

The history of the Catholic church in the Rock Hall area began in 1883 when Fr. Edward L. Brady offered holy mass at Trumpington, the home of R. Bennett Willson. A church was constructed in 1890, and in 1892, a cemetery was added. This card shows the present St. John's Catholic Church in Rock Hall, which was opened in 1955. The card published by Durding's Drug Store, Rock Hall.

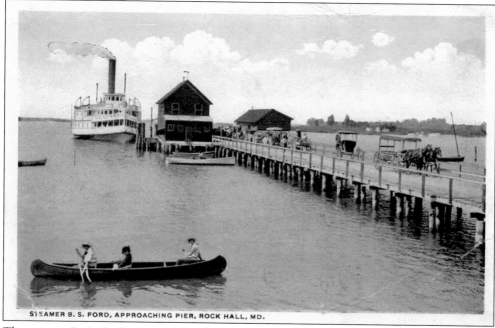

STEAMER B. S. FORD, APPROACHING PIER, ROCK HALL, MD.

The steamer *B. S. Ford* is approaching the pier at Rock Hall. This card was published by Louis Kaufmann and Sons, publishers of local views, in Baltimore. It was made in the United States using "C. T. American Art" and was postmarked Rock Hall, Maryland, on October 31, 1917.

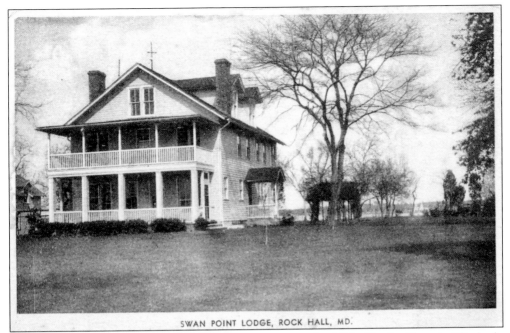

SWAN POINT LODGE, ROCK HALL, MD.

Swan Point Lodge in Rock Hall is shown on this art postcard published by Art Photo in Elizabeth, New Jersey. Rock Hall consisted of a ferry terminus and tavern in the 18th century. The ferry was advertised in 1769 in the *Maryland Gazette* by James Hodes as "Rock Hall—Whitehose to Annapolis, Baltimore-town or elsewhere."

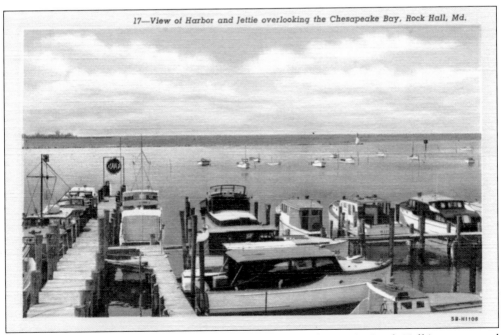

17—View of Harbor and Jettie overlooking the Chesapeake Bay, Rock Hall, Md.

The view of the harbor and jetty overlooking the Chesapeake Bay in Rock Hall is on postcard No. 17 (5B-H1108) published by the Harry P. Cann and Brothers Company, Baltimore, in genuine Curteich-Chicago "C. T. Art-Colortone."

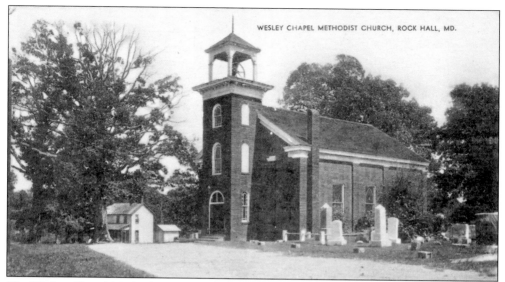

The Wesley Chapel Methodist Church in Rock Hall is believed to have been established as far back as 1829. The name chosen for the church at that time was the Wesleyan Chapel. Public school was permitted in the building so long as it did not interfere with public worship. The church was renovated in the early 1900s and stained-glass windows were installed. A new church hall was completed in 1928 and included a stage. This card was published by the Mayrose Company Publishers, New York.

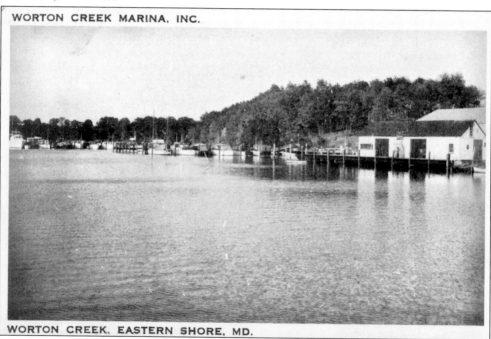

Worton Creek Marina, Inc., Worton Creek, is located just off the Chesapeake Bay. The card states, "Complete Gulf Marine Service, Groceries, Dockage, Railway, Repairs, Restaurant, Showers." Worton Creek Marina continues to operate today as a full service marina. This card was postmarked Chestertown, Maryland, September 9, 1960, and published by Ruth Murray Miller, Philadelphia, Pennsylvania.

This card shows South Church Street in Still Pond. Still Pond is said to take its name from nearby Still Pond Creek. The Native American words "Steel Bone" are marked on Augustine Herman's Map of Maryland of 1672–1673 as "Steel Bone Creek." Land records refer to this area as "Steel Pone." The Martinet Map of 1860 designates Still Pond as "Still Pond X Roads." Still Pond is home to the Still Pond United Methodist Church, which claims it represents the oldest continuous preaching place or organized Methodism in the Delmarva Peninsula Annual Conference.

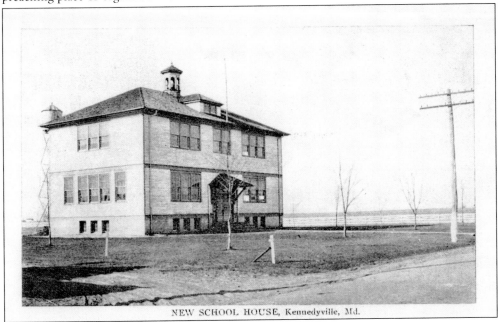

The new schoolhouse still stands today in Kennedyville. It has been used for a number of things since it closed as a school. The name Kennedyville has been associated with a J. Kennedy, a Pennsylvanian, who purchased the land expecting the railroad to follow.

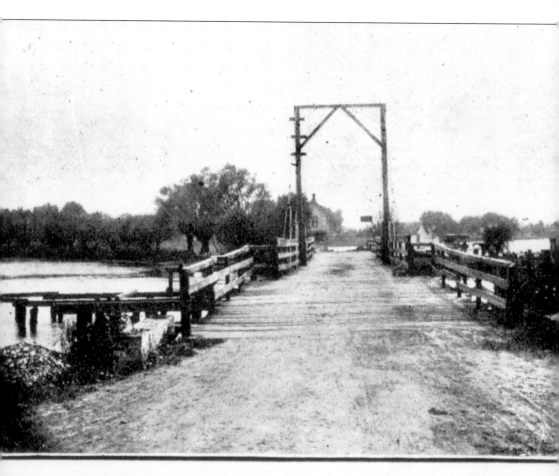

Bridge—Crumpton, Md.

The first bridge from Crumpton into Kent County over the Chester River was built in 1865 and was a wooden drawbridge operating on a turntable that was pushed around by a paid "bridge tender." The modern bridge of today was dedicated in 1951. The Chester River is known to be narrower in this area.

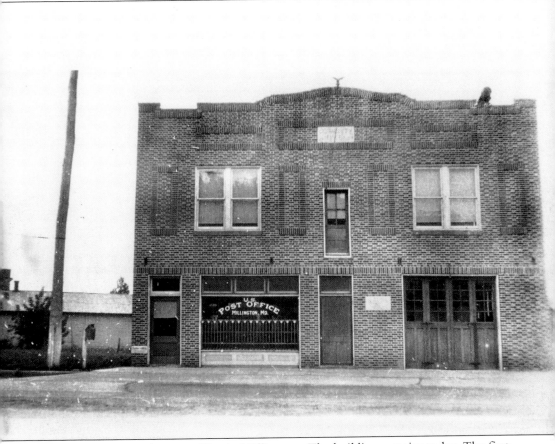

This building was once the post office in Millington. The building remains today. The first known inhabitants of this area were the Matapeake Indians. By the order of the county court in 1696, Daniel Jacobs operated a ferry service near Millington. Known as Head of Chester, the town began from a land grant to Daniel Massey dated August 4, 1754. Millington was originally chartered in 1798 and incorporated in 1890.

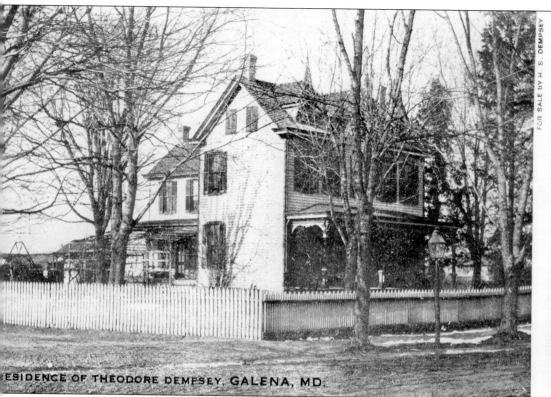

ESIDENCE OF THEODORE DEMPSEY. GALENA, MD.

This residence of Theodore Dempsey is located in Galena, once known as Downs' Crossroads. George Washington stopped in Galena in 1774 en route to and from his first Continental Congress, and he traveled through Galena on his eight visits to Kent County. The name Galena stems from a type of pure silver that was purportedly discovered in the area in 1813. It has been said that the silver was never mined because the townspeople feared the British would discover and take it.

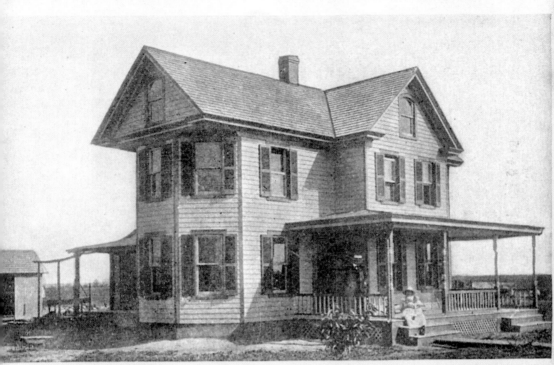

PRESBYTERIAN MANSE, Kennedyville, Md.

The Presbyterian Manse in Kennedyville is shown here. The Presbyterian church in Kennedyville was dedicated in 1875. The church was a frame Victorian style and was later known as the First Pentecostal Church. The "Old Brick Church," which was located about two miles east of Kennedyville, was organized sometime prior to 1736. It continued in active operation until some time after 1866. An outgrowth of Old Brick Church was the Georgetown Westminister Presbyterian Church, which was erected in 1872 and was a sister church to the one in Kennedyville, built two years later. Both received members by letter from the original Old Brick Church.

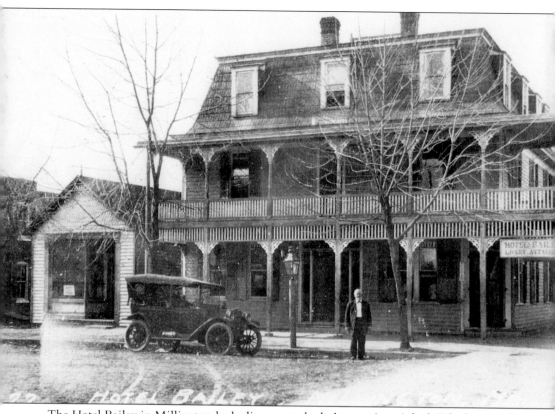

The Hotel Bailey in Millington had a livery attached. At one time, it had 17 bedrooms. It was built in the early 1900s at a cost of $3,900 by owner J. F. Bailey. Millington was founded in 1794 by Thomas Gilpin on a 39-acre tract of land, which included a mill. It was known at the time as London Bridge. The name Millington may be associated with either Richard Millington, who owned a portion of the land where Millington is situated, or because of the many mills that once operated there. The post office name was changed to Millington in 1827. It had earlier been known as Bridgetown and as Head of Chester since several streams in the town join to form the Chester River.

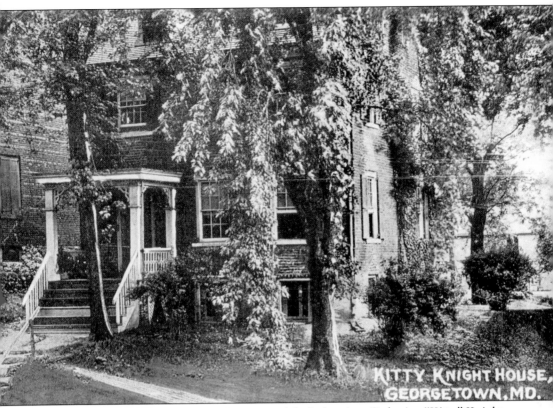

KITTY KNIGHT HOUSE, GEORGETOWN, MD.

The Kitty Knight House in Georgetown is renowned for its heroine, Catherine "Kitty" Knight. She saved the William Henry House and the Archibald Wright House, both located next door to one another in Georgetown, from destruction by fire in 1813. They were later joined and enlarged to form the Kitty Knight House of today.

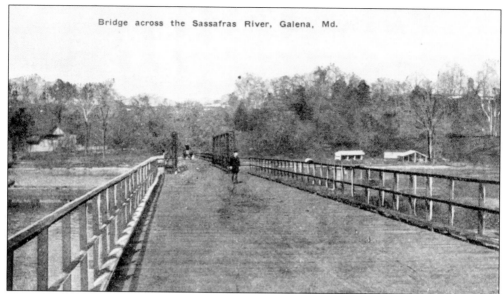

Bridge across the Sassafras River, Galena, Md.

The bridge across the Sassafras River in the upper part of Kent County begins at the bottom of the hill in Georgetown and ends in Cecil County in Fredericktown. The Kitty Knight House offers an imposing view of the bridge from Kent County and those crossing the bridge from Cecil County into Kent County have a bird's-eye view of the two large marinas and all of the boats.

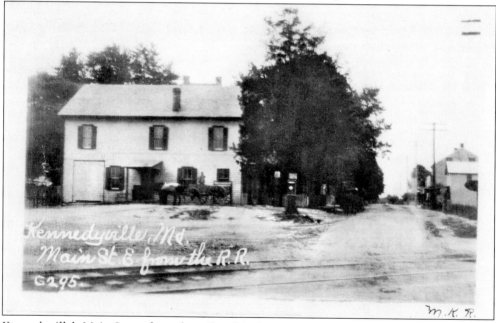

Kennedyville's Main Street from the railroad is shown on this postcard. The 1877 *Atlas of the Eastern Shore of Maryland* lists the following businesses in Kennedyville: William S. Culp, carpenter and builder and manufacturer of peach baskets; C. H. J. Sparks, proprietor of Cash Store, offered a line of dry goods, notions, hats, caps, boots, shoes, and other articles usually kept in a country store; E. Anderson was a wheelwright and did all kinds of repairing, including carts, wagons, and carriages and all farming implements; B. F. J. Sparks was the proprietor of Sparks' Mills, where he manufactured the "best grades of family flour."

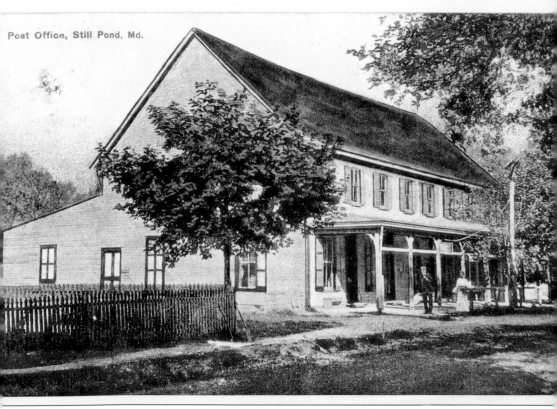

Post Office, Still Pond, Md.

The village of Still Pond claims it was the first place in the state of Maryland where women voted. The Martinet Map of 1860 designates the area we know today as "Still Pond X Roads." By the time of the 1877 atlas, the village had become Still Pond P. O. (Post Office). It is also home to the Still Pond United Methodist Church, which dates back to 1853. The church was extensively remodeled in 1882, and there were further renovations in 1912 and 1945.

BIBLIOGRAPHY

Adams, Charles S. *Roadside Markers in Maryland*. Shepherdstown, WV: Charles S. Adams, 1997.

Bourne, Michael O. *Historic Houses of Kent County*. Chestertown, MD: The Historical Society of Kent County, Inc., 1998.

Chestertown 250th Anniversary Committee. *The Chestertown Story*. Chestertown, MD: 250th Anniversary Committee, 1956.

Dumschott, Fred W. *Washington College*. Chestertown, MD: The College, 1980.

Forman, H. Chandlee. *The Rolling Year on Maryland's Upper Eastern Shore*. Centreville and Chestertown, MD: Circulated by Corsica Bookshop, 1985.

Graham, John L., AIA. *The 1877 Atlases and Other Early Maps of the Eastern Shore of Maryland, Bicentennial Edition 1776–1976*. Salisbury, MD: Wicomico Bicentennial Commission, 1976.

Holly, David C. *Steamboat on the Chesapeake, Emma Giles and the Tolchester Line*. Centreville, MD: Tidewater Publishers, 1987.

Horsey, Patricia O. and Kathleen B. White. *Chestertown, Maryland, An Inventory of Historic Sites*. Chestertown, MD: Town of Chestertown, 1981.

Horsey, Patricia Joan O. *Chestertown, Maryland History 1978 through 1993, State of the Town Addresses*. Chestertown, MD: Delmarva Publications, 2004.

Janson-LaPalme, Robert. *Chestertown: An Architectural Guide*. Chestertown, MD: Town of Chestertown, 1985.

Johnson, Robert J. *Gravesend: Serene But Still Profound*. Rock Hall, MD: American Revolution Bicentennial Committee of Rock Hall, 1975.

Keatley, J. K. *Place Names of the Eastern Shore of Maryland*. Queenstown, MD: The Queen Anne Press, 1987.

Kent County Bicentennial Committee. *Kent County Guide*. Chestertown, MD: Kent County Bicentennial Committee, 1976.

Kent County Historic Trust Brochures.

Kent County Tourism Office. *A Walking Tour of Old Chester Town*. Chestertown, MD.

———. *Driving Tour of the Kent County Peninsula*. Chestertown, MD.

Rock Hall Commemoration, Inc. *Knee Deep in History Souvenir Booklet*. Rock Hall, MD: Planning Committee of Rock Hall Commemoration, Inc., 1957.

———. *Rock Hall Historical Collection*. Rock Hall, MD: Planning Committee of Rock Hall Commemoration, Inc., 1958.

Sutton, Stanley B. *Beyond the Roadgate: Kent County, 1900–1980*. Chestertown, MD: S. B. Sutton, 1983.

The Crumpton Candlelight Tour Association. *A History of Crumpton*. Crumpton, MD: The Crumpton Candlelight Tour Association, 1992.

Thompson, William L. *Washington, The College at Chester*. Chestertown, MD: The Literary House Press at Washington College, 2000.

Usilton, Fred G. *History of Kent County, Maryland, 1630–1916*. Chestertown, MD: Perry Publications, 1980.

———. *"City on the Chester," History of Chestertown, Kent County, Maryland 1650–1899*. Chestertown, MD: Wm. B. Usilton and Son, Printers, 1899.

INDEX